watercolo
in 10 steps

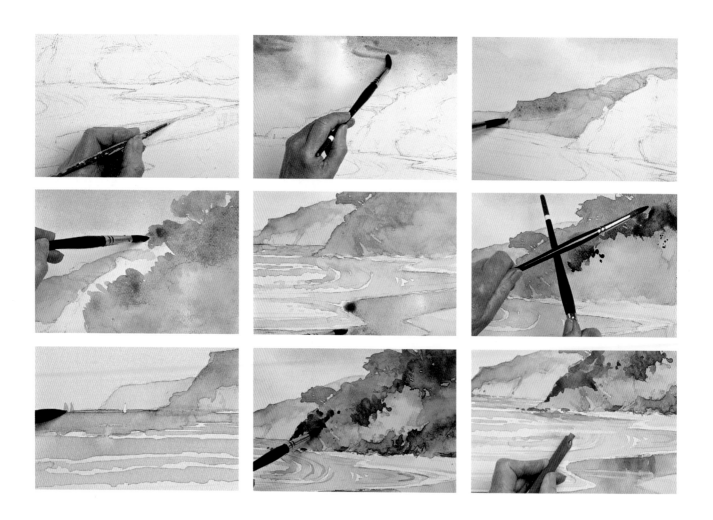

watercolour
in 10 steps

Patricia Seligman

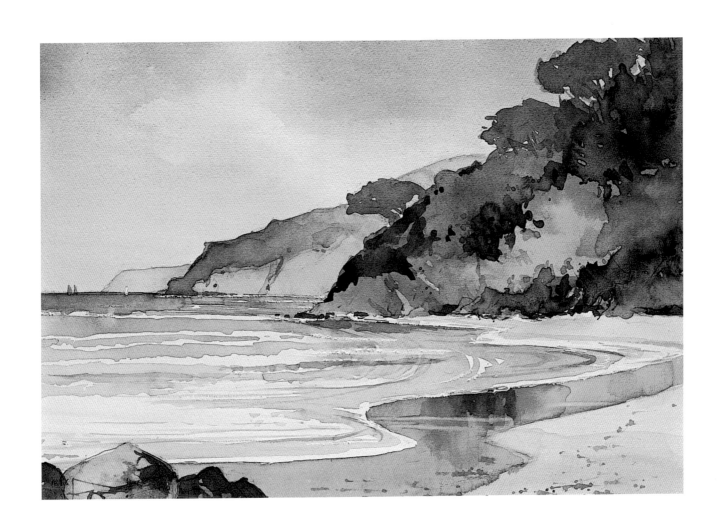

hamlyn

First published in Great Britain in 2005 by
Hamlyn, a division of Octopus Publishing Group Ltd
2–4 Heron Quays, London E14 4JP

Distributed in the United States and Canada by
Sterling Publishing Co., Inc.
387 Park Avenue South, New York, NY 10016-8810

ISBN 0 600 61370 4
EAN 9780600613701

A CIP catalogue record for this book is available from the British Library

Printed and bound in China

10 9 8 7 6 5 4 3 2 1

contents

introduction

You have set yourself a challenge and are ready to learn to paint in watercolour, or to develop your skills if you have already made a start. In this book, in just ten steps, we are going to work up to painting a still-life composition of fruit in watercolour. It may seem like a challenge too far but, as every element of the still-life painting is considered in detail before you start the main painting, you will have thought through the potential problems and worked out ways of solving them.

The ten steps start with exploring your palette of colours, looking at their characters, ways of mixing them and trying them out in useful techniques. This will give you a chance to get used to the brushes and the individual properties of the paints. Then we will focus in on the separate parts of the still life: each of the five fruit, the ceramic jug, the cloth and the background. The fruit will be studied with a watercolourist's eye, editing information, looking at tone and exploring colour mixes and likely techniques. Finally, in **Step 10 composition**, before you start painting the still life, we will look at ways of exploring the options for the composition – the viewpoint, the light source and arranging the fruit so that it makes an attractive, balanced picture.

Learning to control and predict how watercolour paints are going to behave is a testing but exhilirating experience which will give you many hours of pleasure. The outcome – the paintings – will give others pleasure, too.

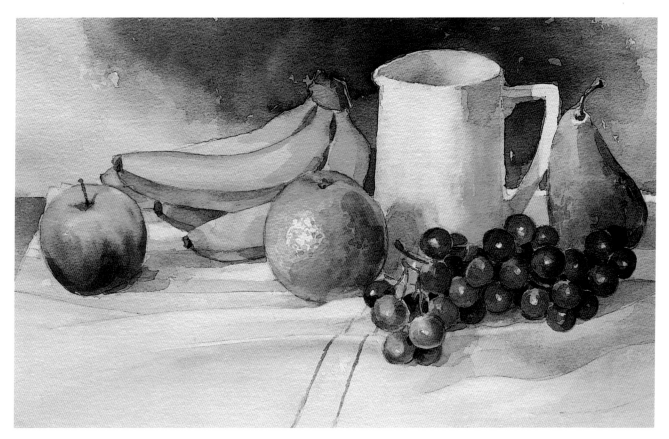

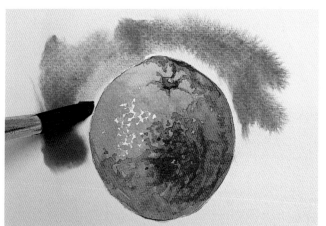

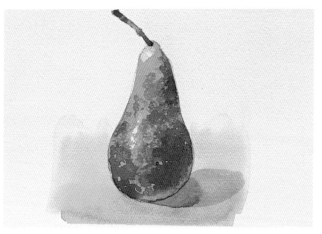

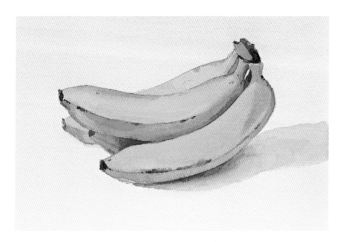

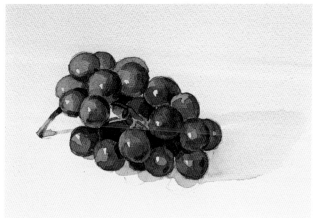

before you begin

choosing the right materials

To achieve results that you can be proud of in watercolour, you need to use good quality materials. The pleasure of a simple stroke of paint on paper only comes from a brush made especially for the art, artist's quality paints, and paper created to extract the best from them both. To learn and progress, you need to gain some satisfaction from your work and investing in the best tools and materials will help you to achieve this. However, the good news is that only a few items will be needed to get going. This section will guide you through the options and recommend those few necessary items.

Like everything, it is fun to buy the kit but to make progress you have to use it. Therefore, this section is not just for reading and looking at the pretty pictures. Try out the techniques yourself; it is a good place to start. You will only have to put the brush into the water and paint onto the paper. I can assure you that once you have done this, you will be captivated. The fusion of colours as they burst into one another on the paper will have you hooked. So buy the few good quality materials recommended in the shopping list (right) – a good brush, some watercolour paper and a few paints – and, by following the simple instructions, you will soon be on the way to painting in watercolour.

Shopping list

A4 pad of 'not' paper, 30 cm x 21cm (12 in x 8¼ in), 300 gsm/140 lb
Masking tape
Masking fluid
Drawing board (piece of wood or polystyrene, approximately 60 cm x 90 cm/2 ft x 3 ft)
Prop for drawing board (block of polystyrene, book or house brick)
Small selection of brushes, including a size 12 half-synthetic sable brush and a size 6 round brush
Cheap, flat hog-hair brush, size 6, for correcting mistakes
Cheap small brush for applying masking fluid
2 mixing palettes
Putty eraser

Basic palette

Phthalocyanine Red
Quinacridone Gold
Ultramarine Blue
Alizarin Crimson
Lemon Yellow
Phthalocyanine Blue

Guest paints

Cobalt Blue
Indigo
Dioxazine Violet
Brown Madder
Quinacridone Red
Payne's Gray
Permanent Rose
Quinacridone Magenta
Cobalt Turquoise
Winsor Green
Prussian Green
Translucent Orange
Transparent Yellow
Green Gold
Burnt Sienna
Raw Sienna

PAPERS

Using the right paper for your watercolour painting will help you to produce good results but the selection on offer can be confusing. Beginners in watercolour tend to think that they do not deserve the more expensive watercolour paper: cartridge, or drawing, paper will do fine, they think. Unfortunately, thin paper with no texture to it will not respond well to washy paints, distorting and drying unevenly; it will disintegrate if you try to wash away a stray spot of colour. As you will see, watercolour paper is tough and can withstand reworking, lifting off paint, scratching out of highlights and many other attacks on its surface and still look pristine. Let us look at the options.

Surface texture

There are three main types of paper used for watercolour painting: hot-pressed, cold-pressed, known as 'not' ('not hot-pressed'), and rough. Hot-pressed has a smooth surface and is generally used for pen and line work and detailed, often small-scale painting with drier applications of paint. 'Not' has a slightly textured surface, which gives the stroke an interesting edge. Rough paper is just that. It has a visible texture to it often with dips into which the paint collects, giving the stroke a shimmering depth. There are many degrees of roughness from the various manufacturers, and handmade papers offer a further selection of textured surfaces.

Hot-pressed paper: This does not absorb paint so if the brush is loaded ready for a broad stroke the paint will tend to puddle, drying slowly and unevenly with a hard edge. You can see the dark puddles of collected paint here. This paper is mostly used for detailed work where one layer of dryish paint is required. Botanical flower painters use it for their stunning work, building up one thick layer of paint with a small brush and tiny brushstrokes.

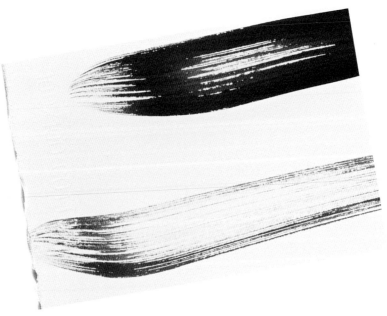

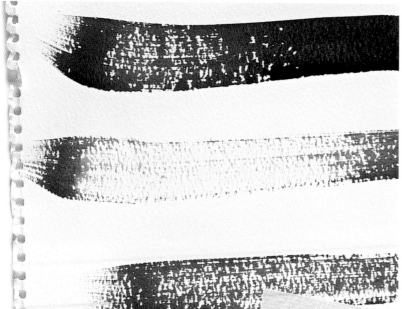

'Not' paper: This is a useful all-rounder that absorbs the paint evenly, which makes it easier to control washes. The surface is robust enough to survive repeated rescue operations, which makes it a good choice for beginners.

Rough paper: This can be wonderful, emphasizing the typical watercolour broken edge of the brushstroke and creating texture. You can see how the paper has soaked up the paint, breaking up the stroke almost immediately. It encourages impressionistic painting and imprecise edges.

Paper weight

Watercolour paper comes in various weights described in grams per square metre or pounds per ream (500 sheets) – 300 gsm paper is equivalent to 140 lb. Light papers are to be avoided if you want to paint in wet washes of paint: the paint cockles the paper into ripples causing the paint to dry unevenly in the dips. Heavy papers are expensive. What you want is the heaviest paper you can use without having to stretch it. You will want to avoid stretching paper at this stage, as it involves soaking the paper and fixing it to a board. If you are using a medium-sized sheet, 300 gsm (140 lb) is adequate. Fix it to a board along all four edges with masking tape to keep it flat (see page 25). Masking tape will also create an attractive border around your painting because it prevents the paint reaching the paper.

Cockled cartridge (drawing) paper: With a wet wash and too thin paper, the paper dries cockled with the paint concentrating in the dips. Don't panic! If your paper does cockle, if you have taped it to a board and it is 300 gsm (140 lb) or over, it should return to its former perfect flatness once dry.

Pad of paper or single sheet

Pads of watercolour paper come in the various types, spiral bound or just taped at the top. Smaller ones are useful for watercolour sketching on the move, where you will be painting smaller areas with restricted washes. Sheets from larger pads can be torn off and taped onto a board. A pad option, useful for travel, comes glued around all four sides so that you can paint straight on to the paper and it will not cockle with a wash. All these different pads come in various sizes, weights and textures.

Many artists prefer to buy paper in large single sheets, tearing or cutting them to the size they want. Most art stores have a good selection of such papers made by various manufacturers. The surface of the paper differs between the top ('right') side and the underside ('wrong'). Good papers have a watermark that is visible if you hold them up to the light. Checking that the watermark is the right way around will confirm the right side of the paper.

BRUSHES

Brushes come in an overwhelming range of sizes, shapes and hair type. They vary in size from ultra fine 000 – up to a generous 14 and beyond. Tradition has the watercolourist laying flat washes with large brushes, flat or round, treating broad areas with a medium round brush and using a small brush for detailed work at the end. In fact, as we show in this book, most watercolour painting can be happily executed with a large round brush, using the tip for detailed work and, with a little pressure, extracting the paint stored in the body of the brush for washes.

If, right from the start, you use just the one large round brush, you will quickly discover its potential and save yourself much wasted time, interrupted concentration and money. Using a larger brush will also keep your washes broader and prevent you from getting bogged down in fine details.

Artists, however, all end up with their own personalized collection of brushes and painting tools. In due course, you will try them all – round, flat, filbert, rigger – and you may find the odd one that suits your style or subject matter.

Brush shapes

The shapes of different brushes have evolved for certain jobs. The round brush can paint details and carry large amounts of paint; the flat is useful for laying flat washes or cutting in around a complicated shape. There are many other shapes and their uses will suggest themselves as you expand your techniques.

Using your brush

Try out your brush, putting it through its paces. Keep your hand relaxed and let the brush do the work. See how many different marks you can produce: try delicate dots and broad sweeps.

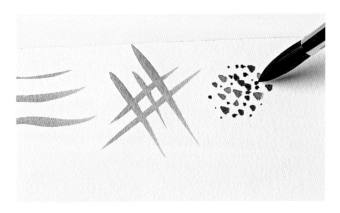

Brush tip: Delicate marks can come from the very tip of the brush. Hold it upright, with minimal pressure using your fingers rather than your wrist to manipulate the brush.

Broad stroke: Use the body of the brush for broader washes, applying gentle pressure to squeeze out the paint that is stored here. Keep the brush upright.

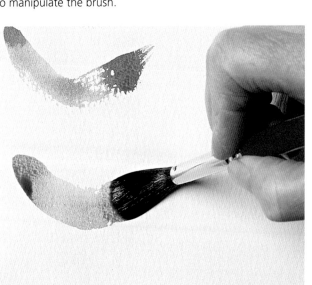

Curves: Use the natural spring of the hairs to follow a curve.

Rolling: Roll the brush from side to side for an interesting effect.

Synthetic or sable?

The artists featured in this book paint with brushes that are a mixture of sable and synthetic and their paintings are a testament to their tools. These half-sable brushes are much cheaper than all-sable brushes and they are better able to take the rough treatment a beginner might unintentionally give them. Many artists only use sable brushes, particularly the Kolinsky sable, but they are expensive. If looked after carefully, however, such a brush can last a lifetime. Sable brushes have a springiness that means the brush returns to its shape after every stroke and this makes them responsive. They also carry more paint without losing their shape.

Shaping a brush: Clean your brush gently in cold water after use and dry it by blotting with a tissue. Shape the brush into a point with your fingers and dry out upright in a jam jar or pot.

Looking after your brushes

Try not to use your good brushes for mixing, loosening up paint in pans, applying masking fluid, or working at mistakes. In fact, nothing where the hairs are rubbed or scrubbed or twisted into extreme positions. Use cheap or old brushes for these jobs – not only to save yourself money but also to preserve the life and shape of your good brushes.

Other painting tools

You will find before long that you accumulate a wonderful range of tools to paint with alongside your brushes. Our artist's box contains an old hog-hair brush used for rubbing off paint that has gone astray on the paper; a children's paint brush used for applying masking fluid; a toothbrush for stippling; a credit card for any straight line – a fence post or flower stalk; cotton wool swabs, useful for softening edges or cleaning up stray washes; and a number of small real sponges for textural effects. Items from this strange collection make star appearances in the course of the book.

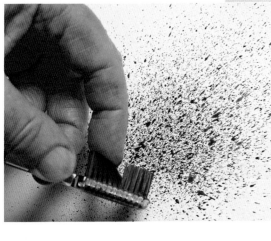

Credit card: Useful marks can be made with a credit card dipped in paint.

Sponge: A sponge creates interesting textural effects.

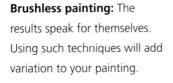

Toothbrush: A toothbrush produces a fine spatter of paint when the bristles are pulled back.

Brushless painting: The results speak for themselves. Using such techniques will add variation to your painting.

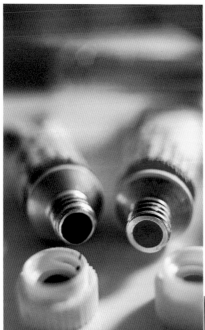

PAINTS

Watercolour paints are beguiling – little pans and tubes of pure colour that promise so much. You can buy a smart box of paints in your art store for almost any sum of money. However, you do not have to spend too much.

Start off with the basic colours suggested in the Shopping List on page 10 and add 'guest' colours, also listed there, when required. Once you have your basic colours, spend time getting to know them and finding out their quirks. Create orderly colour charts but play around with them, too.

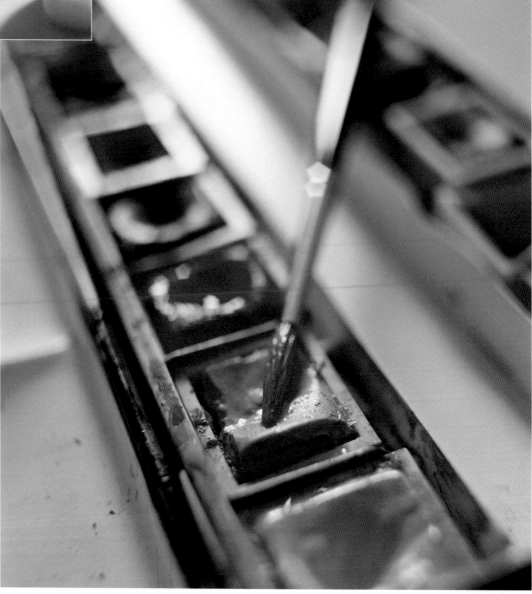

Tubes or pans

Watercolours come in tubes and pans – the small blocks of solid paints that you find in a traditional paint box. Artists usually prefer one or the other and are always convinced that their choice is the only way to paint. Whatever you buy, make sure the paint is of good artist's quality. Cheap paints have a larger proportion of filler, which means less pigment so the colours are not as vibrant and your results will not be as good.

Tubes

In this book we mainly use tubes. It is easier to mix a quantity of paint with tubes as the dried pans need to be worked to release the paint. With tubes the paint comes out soft and ready to go. Tube users say they are more economical and easier to transport.

Pans

Some artists like to have a wider choice of colours ready for use as found in a conventional paint box. They like to hover and dip at will rather like a humming bird choosing a flower. You can buy individual pans in the usual half-pan size or double-sized full pans. Small paint boxes are easy to pack into a bag for travel but a larger box allows you to accommodate full pans for those colours you use a lot.

Colours

A basic palette of colours can be mixed to produce almost any colour required. Artists vary in their choice of a basic palette, choosing colours that suit their subject matter – landscape, marine or flowers. Some artists use the same basic palette for all their painting, and others add 'guest' colours for certain subjects: convenient ready-mixed greens, such as Hooker's Green, for a landscape, Payne's Gray for cool shadows, or earth colours such as Burnt Sienna and Yellow Ochre, which are generally useful.

Palette of six colours

For our still life, we will need a basic palette of six colours (see shopping list, page 10). There will be two each of the primary colours, red, blue and yellow – warm and cool versions of each colour. Warm primaries chosen were Phthalocyanine Red, Quinacridone Gold and Ultramarine Blue, and cool primaries, Alizarin Crimson, Lemon Yellow and Phthalocyanine Blue. A warm red will tend towards yellow and a cool red towards blue (see colour wheel, page 31). Having the two versions of each colour makes it possible to mix a far wider range of hues (see mixing chart, page 29) and alternating warm and cool colours in your painting will give it light and depth.

Getting to know your colours

Each colour has a character of its own, so the first thing you will need to do is try them out and get to know them. You will notice differences as soon as they are squeezed out of their tubes, even though the paint manufacturers have tried to standardize them: some are more oily looking, others drier. When you mix them some seem a little grainy, others smoother. Some are good mixers, some are strong, others less so. Mix them with a little water as shown on page 22, and try out each of the six colours across the page.

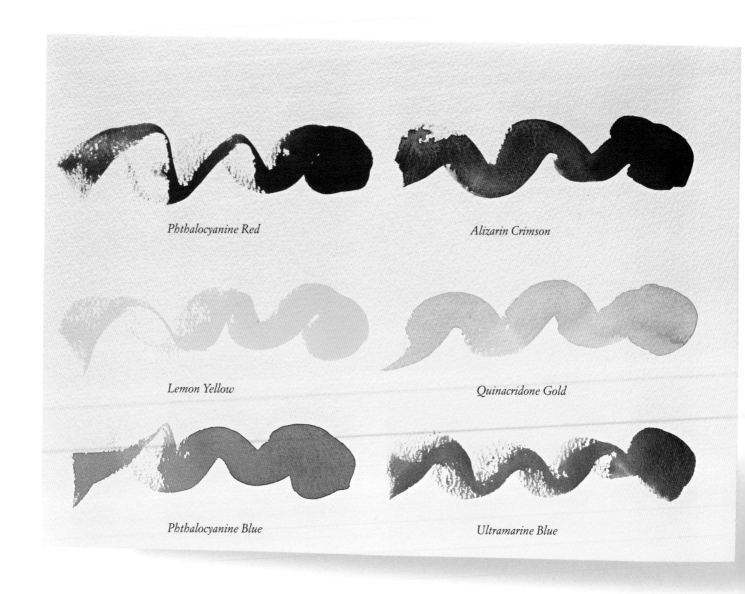

Phthalocyanine Red

Alizarin Crimson

Lemon Yellow

Quinacridone Gold

Phthalocyanine Blue

Ultramarine Blue

Transparency

The colours in our palette were chosen because they are transparent. Transparent paints fully take advantage of the white paper beneath, which can shine through the superimposed glazes giving them a particular brilliance.

Texture

Paints vary in their texture. You will notice this as you squeeze out the paint onto your palette or work the paint in the pan: some are grainier, some more luscious.

Staining power

Some colours stain the paper more quickly. This can be a problem if you want to correct a mistake and take paint off the paper.

Strength

Some colours are much more powerful than others as you will discover when you start mixing them. A touch of Phthalocyanine Blue will take over almost any other colour so it has to be introduced carefully, always adding small touches of the stronger paint into the weaker.

Dilution: See how colours change by adding water. Take three primaries – Phthalocyanine Red, Lemon Yellow and Phthalocyanine Blue – and paint them in three dilutions, strong, medium and weak across the page. The results are surprising and the nature of the hue appears to change.

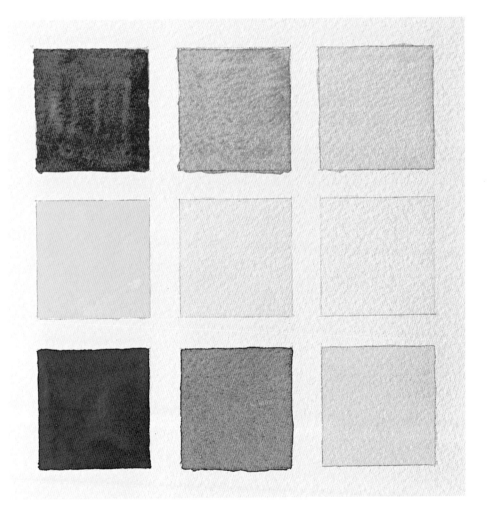

PREPARING TO PAINT

If you are using tubes, squeeze out small blobs of paint from your chosen selection of colours into separate wells on a mixing palette. This is your main palette and the colours should be kept pristine. Each colour will be mixed with a little water. Use another mixing palette for mixing together colours from your main palette. The rule is that only clean brushes, or a brush reloading, can take paint from the main palette. In time it becomes second nature.

Mixing paints on a palette

For users of paint boxes, any mixing can be done on the fold-out area most boxes come with, mixing larger washes in the wells in the lid. There are other purpose-made palettes available at art stores but for larger mixes of paint, any receptacle will do – yogurt pots and other food packaging provide numerous options. Make sure they are thoroughly cleaned of any grease.

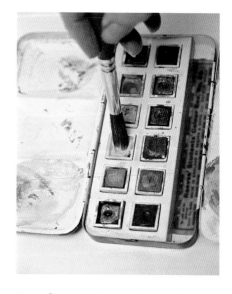

Box of pans: When getting ready to paint with a paint box of pans, loosen up the paint first with an old brush.

Main palette

Set out your palette with your chosen colours. The idea is to have these colours ready for use, diluted only slightly to make them easy to handle.

1 Squeeze a small amount of each colour into the wells. Here, the six bowls of a flower palette are very convenient for laying out the basic primary colours, ready for mixing.

2 With a clean brush, transfer water from your clean water jar to the well. Tap the brush on the side of the well to release it and work it carefully into the paint. Mix so that you have a strong yet manageable colour that you can dilute or combine with other colours on the mixing palette.

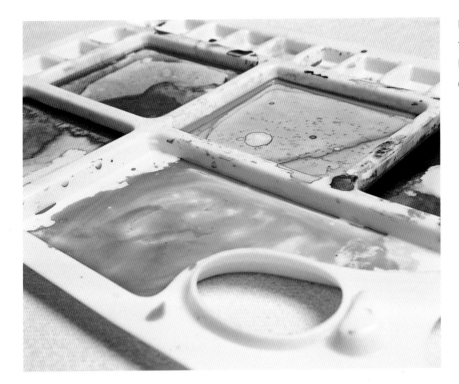

Mixing palette: Primary colours from the main palette are mixed together here to form secondaries and beyond (see Colour wheel, page 31).

Mixing palette

Your mixing will take place on a mixing palette, taking paint from the main palette with a clean brush and adding water.

Water jars

Watercolours should be kept clean and pure otherwise the true beauty of these paints will be lost. The secret is to have two jars of water, one for clean brushes – used for diluting the paint – and one to wash dirty brushes.

Cleaning your brush

Before cleaning your brush, always take off as much paint as you can back into the palette by scraping the brush against the side. Now dip it in the cleaning water and shake to release the paint. Press it against the bottom a few times and dry it on some clean tissue.

Tissue

Tissue or kitchen paper is important to the watercolour painter. Most artists will paint with a brush in one hand and a tissue in the other. It has many functions, amongst others, to dry the paintbrush, to mop up stray paint, to take back too much paint and to soften edges. It is invaluable.

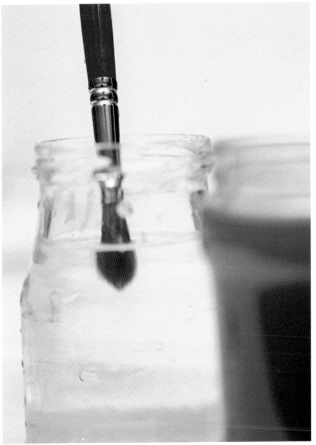

Water jars: Choose a reasonably large jar so that you do not have to keep changing the water, and one that is preferably made of glass. Plastic containers are knocked over easily.

SETTING UP TO PAINT

You can paint just about anywhere and any time. We all dream of a purpose-built studio with large windows through which the north light falls but most of us paint happily at the kitchen table. Really, there is no special equipment necessary to get going. Make sure the chair is at the right height so you are comfortable and that the lighting is good enough. Try to start with all your materials assembled. It is annoying to have to break off and fetch things. In addition, do make sure you have enough space around you for your paints, water and other tools. It is easier to work and saves you knocking over the water jar every time you move anything.

Lighting

Certainly, it helps to paint by daylight as the colours are easier to judge, but a good desk lamp will be adequate. Try to organize the light so that it is not directly behind you because you will cast a dark shadow on your paper when you are painting. Painting outside requires your ingenuity to make yourself comfortable enough with access to your paints and water. The light will only be a problem in that it changes as the sun moves across the sky.

Drawing board

It helps to have your drawing board at an angle so that the paint drips downwards rather than in every different direction. Rest the top of your board on a heavy book or use a convenient block of polystyrene or even a house brick. Sometimes you will want the paint to go in different directions, in which case, it is easy to remove the prop and lay the board flat on the table.

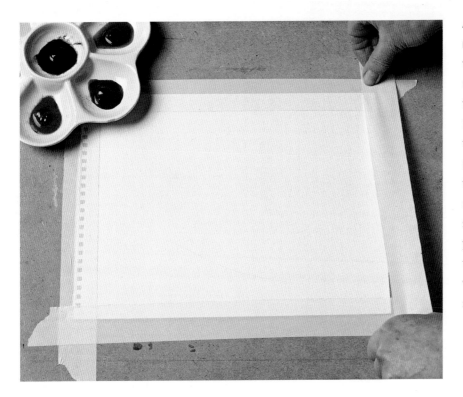

Attaching paper to board with masking tape: To keep the paper flat, tape your sheet onto a board with masking tape. Run the tape along the top, centring the paper on the board. Make sure it is quite flat before taping the bottom and then the two sides, pressing down all four sides at the end to make sure the paint does not seep underneath. Avoid touching the painting surface or transferred grease may spoil your watercolour washes. The masking tape is low-tack and so is easily removed without affecting the surface, but make sure the paint is dry before you try.

Using this book

Now that you are set up with paper, brush and paints, it is time to start painting. You will start with simple drawings and paintings of fruit, which are paintings in their own right but also preparatory studies for the still-life painting you will tackle in **Step 10 composition**. In this way, you will be able to approach the still life gradually, thinking through potential problems and working out ways of solving them.

In each of the steps we are not only looking at the options open to us in the final painting but also focusing on a particular aspect of watercolour painting so that, before you know it, you will have covered the basic tenets of painting in watercolour. As a result, you will be able to paint your way to a masterpiece, armed with confidence based on forethought and good preparation.

Step 1
exploring colour

focus: understanding and combining colour

Materials
Paper for sketching
Watercolour paper, 300 gsm/140 lb
HB clutch pencil
Round brush, size 12
Flat hog-hair brush
Toothbrush
Clean brush
Tissue/kitchen paper
Watercolours:
• *Lemon Yellow*
• *Phthalocyanine Red*
• *Cobalt Blue*
• *Quinacridone Gold*
• *Ultramarine Blue*
• *Alizarin Crimson*

Mixing colours is an art in itself. As a budding watercolour artist, you should start to look at colours around you and think how you might mix them using your basic palette. Try some ideas out and you will find that the outcome is not always what you expected. For example, as you will see below, red and blue do not necessarily produce a rich purple. We will look at different ways of combining colours, including some less obvious techniques for mixing. By trying out the various combinations in your palette, you will learn to predict the outcome. This will save time when you are looking for the perfect match while you are painting.

Predicting colours: Touching rich but cool Cobalt Blue into a wash of fiery warm Phthalocyanine Red produces a wonderful inky blue-black but not a rich purple as you might expect (see page 30.)

COLOUR CHARTS

These charts show you how some colours mix good clear colours and other tend toward a muddy grey. Muddy colours, otherwise known as neutrals, have an important place in watercolour painting but it is nice to be able to call on them when required, rather than end up with them by mistake. Until mixing becomes second nature, make a chart of the various combinations of the six colours in the basic palette so you can refer to it when searching for a particular hue. Keep it to hand, as this chart will be invaluable to you when you start painting. At first, you will refer to it constantly; after a while less so and finally it will get buried under a pile of paintings.

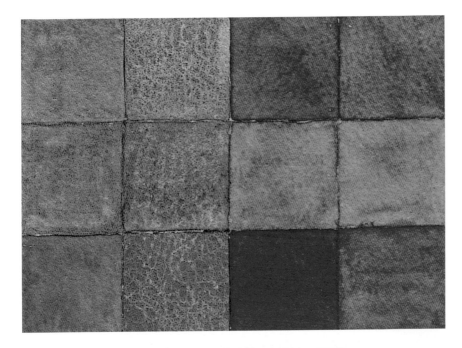

Hues: Look at the variation in the hues mixed by warm and cool versions of the same colour. This is a good reason for choosing a warm and cool version of each primary.

Granulation: You can see the granulation of the paint in the mixes with Ultramarine Blue.

COLOUR THEORY

Understanding colour theory lets you make decisions without having to learn by rote. The colour wheel, right, shows you how the basics work. The three primary colours, red, blue and yellow when mixed, here, spattered together with their neighbours, produce secondary colours – orange, purple and green. These are all good clear colours. The neutralizing of these colours – when they tend towards grey – comes when you mix all the primaries together. This also happens when you mix opposites (known as complementary colours) – red with green, purple with yellow, and orange with blue. This is because you are in effect mixing the three primaries (red + green = red + blue + yellow). Therefore, if you mix a warm red that tends towards orange with a cool blue that tends towards green, you will not end up with a juicy purple but dark grey, because again you are mixing the three primaries. Depending on the proportions and dilution, you can also achieve a blue-grey or a pink-grey. Remember this, as you will need these coloured neutrals.

Colour mixes: You can see in these colour mixes that by mixing on the palette Ultramarine Blue (a warm blue tending towards purple) and Alizarin Crimson (a cool red tending towards purple) a good purple results (left, bottom). On the other hand, mixing Phthalocyanine Blue (a cool blue tending towards green) with Alizarin Crimson (tending towards purple) you end up with a dark blue-grey (left, top).

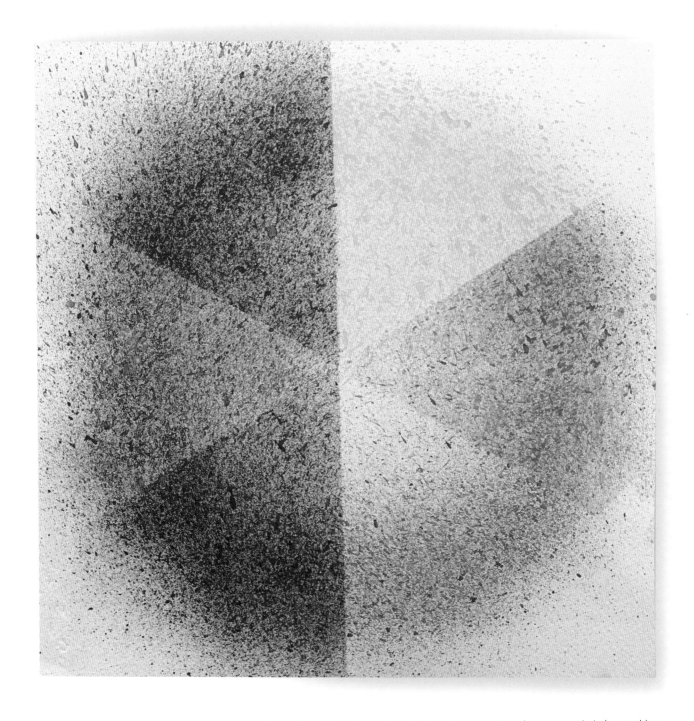

Colour wheel: The three primaries have been spattered over a semi-circle, masking off the other half: first yellow, then red, and finally blue. The three colours chosen were Lemon Yellow, Phthalocyanine Red and Cobalt Blue. The red and yellow make a fine warm orange, and the blue and yellow a good grass green, but the Cobalt Blue, which tends towards green, has produced a dull purplish grey. Notice that being able to see the constituent colours makes the resulting colour look more alive. All these findings will prove useful in your painting. Complementary colours are those opposite on the colour wheel: blue and orange; red and green; and yellow and purple. Try this colour wheel with a different set of three primary paint colours.

HOW TO MIX COLOURS

With watercolours, you can mix on the palette or on paper. If you wanted
a green colour either you can combine blue and yellow paints together
in a palette or you can mix on the paper by superimposing layers of
transparent paint, yellow over blue, to make green, or running the colours
together to make wet in wet. The colours shown in the chart on page 29
can be mixed in your palette and applied to the paper, or the constituent
colours can be mixed on the paper by superimposing transparent layers
of paint: a layer of yellow, covered with a layer of red will look orange if
applied wet on dry (see page 34). Try mixing yellow and red in the palette
and applying it to the paper and then try the same mix optically on the
paper. You can see that the optically mixed orange has more life with more
of the constituent colours visible.

Mixing in the palette

It may seem obvious how to mix colours in the palette but here are a few
useful tips. Add a strong colour into a weaker one, dark into light. Do
not mix the colours together too completely: a mixed colour with the
constituent colours still visible will have more life to it.

Mixing on the paper

There are a number of useful techniques that can be used for mixing paints optically on the paper. These four techniques form the basics of painting in watercolour: wet in wet, wet on dry, dry brush and spattering. There are many other techniques but most of them are variations. Once you have mastered these techniques they can be adapted to produce almost any effect you will need for watercolour painting.

Wet in wet

This technique involves laying down a wash of paint in one colour and then, while the first wash is still wet, adding a second colour. Wet in wet is useful for mixing colours on the page but it produces a host of other effects depending on the dilution of the paint and the time left before the second colour is added. For example, it is useful for blending colours softly into one another. Try some other permutations with different dilutions and with the first layer damp rather than wet – you will achieve a range of effects.

Very wet: Adding wet paint to wet paint will mean that the two colours will fuse into an even mix. By moving the board, you can make sure the added red paint reaches every part of the yellow. Too wet and the wash will be unmanageable.

Less wet: Once the first layer has been painted, leave until the paint stops glistening and then add the second colour. Touch the colour in with the tip of the brush, allowing it to mix. This can be alarming with extreme colour combinations, rather like a moving kaleidoscope. Don't worry. The paint will settle and dry more evenly blended and much paler.

Damp: Here the first application of yellow is allowed to dry for a longer time until it could be described as damp. This time, when you add the red the brushstrokes remain intact – soft-edged and blending with the yellow but not spreading over the whole area.

Keeping control: When painting wet in wet, you can control the mix of washes by tipping the board, or by lifting off with a dry brush or a tissue. With the board tipped up, the paint tends to gather in a pool at the bottom of the painted area. Clean and squeeze off your brush on a tissue then lift off the extra paint by touching the side of a brush gently into the pool.

Wet on dry

This technique involves mixing paint by allowing the first colour to dry on the paper before applying the next colour. You can try this with different dilutions of paint, imitating the mixing in the chart. When dilute transparent washes of paint are used, this technique is called glazing.

Glazing: Paint a wash of dilute blue in a square. Leave it to dry. With a clean brush, take a pale wash of yellow and carefully paint it over the blue. Make the strokes clean and without fuss or you will disturb the blue wash. The result, where the two washes cross, will be a patch of green.

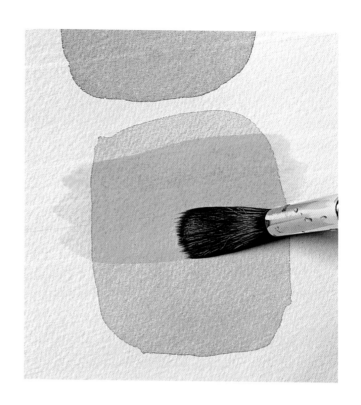

Dry brush

For the dry-brush technique, the first layer is painted flat and allowed to dry. For the second layer, add very little dry, undiluted paint to a clean dry brush and dab off any excess on a tissue. Gently scrub over the top of the first layer. It is more effective dark over light. The dry-brush layer can be executed with the bristles of the brush splayed, as shown in Example 1; lightly stroked over (scumbled), as in Example 2; or stippled with a hog-hair brush, as shown in Example 3. The result mixes the colours optically and produces an interesting textural effect.

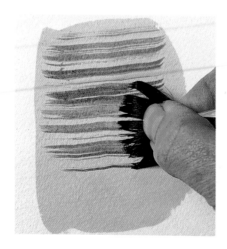

Example 1: A dry-brush layer is applied with the hairs of the brush splayed between thumb and forefinger.

Example 2: A second layer is applied lightly over the dry yellow paint, again using a dry brush.

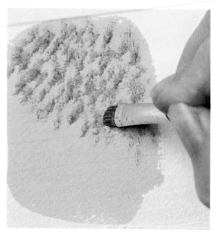

Example 3: A hog-hair brush is used to lightly stipple with dry paint.

Spattering

You can use almost any brush for this mixing technique but a toothbrush works well. Remarkably different effects can be achieved by altering the dilution of the paint, spattering wet in wet (see page 33), or spattering onto a flat wash.

Predicting the outcome

Learning to predict the outcome of mixing two colours on the page takes time. It is truly the wonder of watercolours that you can never be sure and therefore have to be able to deal with unexpected results as part of the process. In the end, if the dried combination of two colours is not what you expected, you can wash them off with a clean brush and water, or superimpose with another wash of paint. This is a good reason for taking the build up of washes slowly.

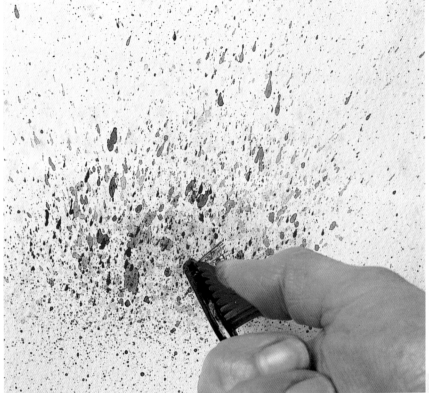

Toothbrush: Dip the brush into the paint and pull back the bristles with your thumb. Allow to dry and then spatter the next colour over the top.

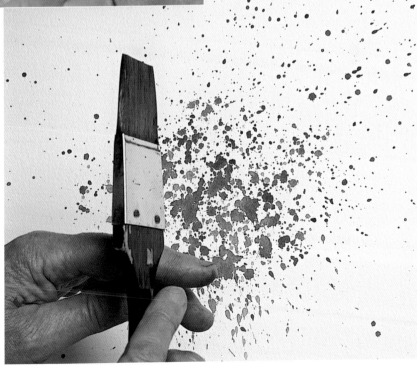

Flat brush: A 2.5 cm (1 in) flat brush produces larger spots of paint. Knock it against your other hand.

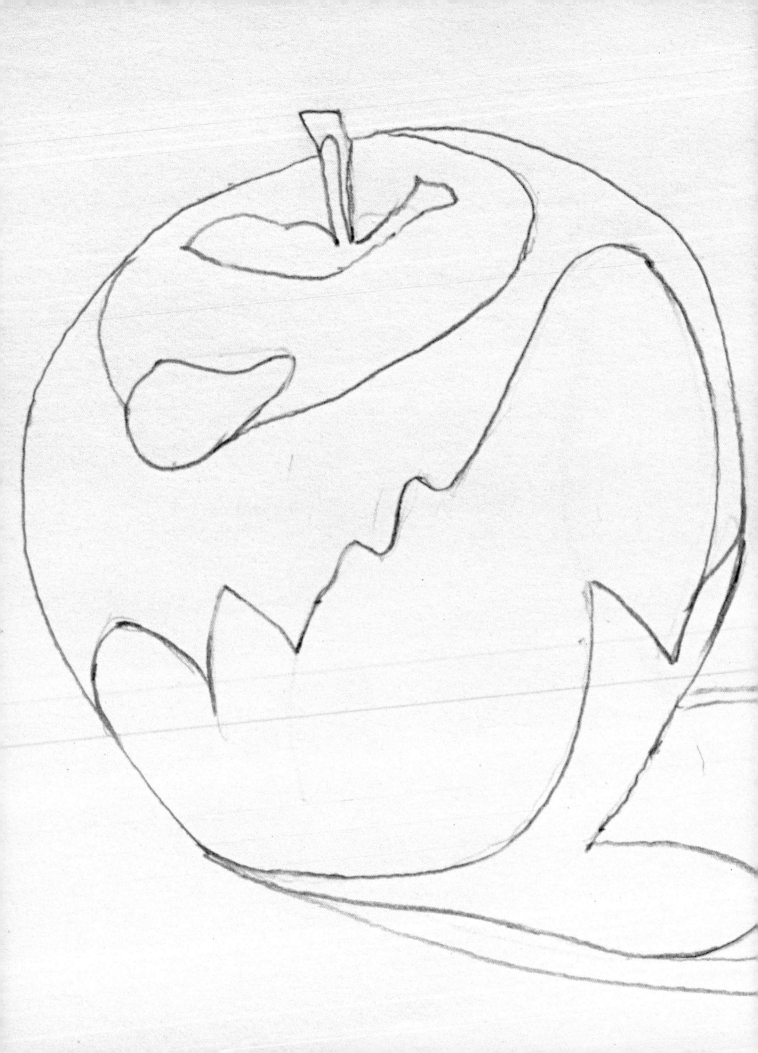

Step 2
preparatory drawing and sketching

focus: apple

Materials

Paper for sketching

Watercolour paper, 300 gsm/140 lb

HB clutch pencil

Round brush, size 12

Clean damp brush

Tissue/kitchen paper

Watercolours:

• *Lemon Yellow*

• *Quinacridone Gold*

• *Alizarin Crimson*

• *Dioxazine Violet*

Any artist will tell you that sketching an object is the quickest way to sear the image onto your retina; to judge what it is that makes this object recognizable – an apple rather than an orange, for example. Most watercolour artists can draw as well as paint. Their sketching days lead to a confidence in their knowledge of a subject, which makes it possible to distil the essence of the subject into a painting. When you are drawing, you find out what is important about a subject. Here we will look at ways of sketching, and at the reasons for producing an under-drawing for your painting.

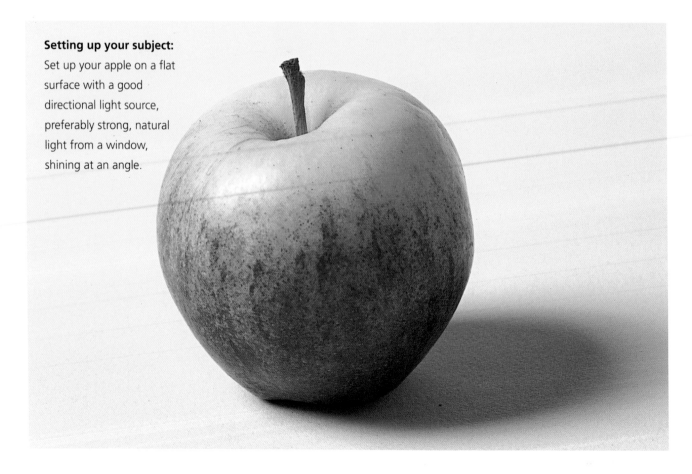

Setting up your subject:
Set up your apple on a flat surface with a good directional light source, preferably strong, natural light from a window, shining at an angle.

THE UNDER-DRAWING

Most watercolour artists map out their painting with an under-drawing that will then be painted over. Some artists produce a carefully considered, detailed drawing while others set off painting with the help of only a few hurried lines to plot the composition.

Your under-drawing must not be too heavy or it will show through the paler washes of the painting. Use an HB or 2H pencil with a sharp point but keep your hand relaxed, so that you don't incise the line into the paper. Try not to use an eraser, as it will spoil the surface of the paper. Rework the line if it is not right. You can carefully erase any lines that interfere at the end of the painting process. If you are worried about drawing onto your clean piece of good paper, you can always practise on another piece and transfer it by tracing. If the paper is thin enough, place it under your good paper, hold it against the glass of a window and let the daylight shine through. Now you can trace the image.

Don't panic!

If your drawing is too small or you want to scale-up an image from a magazine, use the enlarging option on a photocopier and then trace that onto your good watercolour paper.

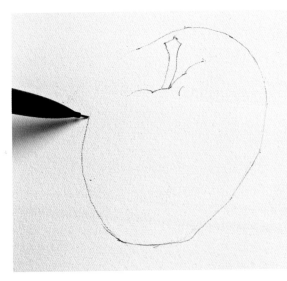

1 Study your apple carefully. When you draw it, try to record what is actually there – you will notice, for instance, that apples are rarely round. The apple will look more realistic if you include any slight distortions and irregularities. Take special care with the stalk and the well in which it sits. An HB pencil will allow you to feel your way around the form, making smooth movements without catching on the paper.

2 Use a harder pencil now and copy the outline of the apple. Keep your pencil on the paper, assessing each angle as you come to it. When you are drawing, think about what makes it an apple: in this case, the shiny, reflective skin. The apple is hard and has a certain weight, too, and this shows in the harsh, clear outline. Imagine if you were drawing an apple carved from wood or one made from sponge. How would they differ? Draw the apple from various angles, life-size if possible. You will see that it is more obviously an apple when you can see the strange sculptural descent to the stalk at the top.

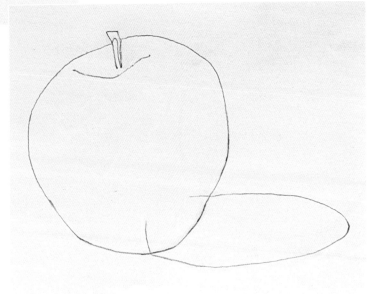

3 Look at the apple from the point of view of tone, particularly the deepest shadows and brightest highlights. Some artists map these out, tracing the outline of the areas of extreme tone, highlights and darkest shadow, and include this in their under-drawing.

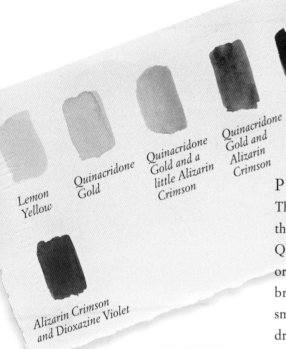

Lemon Yellow

Quinacridone Gold

Quinacridone Gold and a little Alizarin Crimson

Quinacridone Gold and Alizarin Crimson

Alizarin Crimson

Alizarin Crimson and Dioxazine Violet

PREPARING TO PAINT

The apple is a cool yellow with crimson-red markings. For the painting, the yellow part will range from cool Lemon Yellow to warmer Quinacridone Gold. When Alizarin Crimson is mixed with the Gold, an orange-yellow results, and when it is mixed with Dioxazine Violet, a brown-red. Try out some of the wet-in-wet techniques required for this small painting (see page 33). Experiment with leaving the first wash to dry for different lengths of time before adding the second.

Palette and mixes used:
Lemon Yellow; Quinacridone Gold; Quinacridone Gold and Alizarin Crimson; Alizarin Crimson; Alizarin Crimson and Dioxazine Violet; Dioxazine Violet

Blending wet in wet: The gradations of colour from yellow to red suggest adding the colour wet in wet. Try some colours out before you begin. First, try the cool Lemon Yellow with the warm Quinacridone Gold yellow. Then add the Quinacridone Gold and Alizarin Crimson mix. If the paint is not too dilute and is allowed to sink into the paper a little before adding the next colour, it will not spread too much.

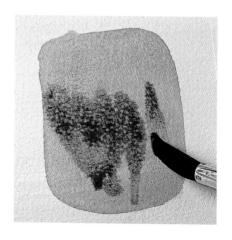

PAINTING THE APPLE

Have your apple ready drawn up on your good paper, which you will need to tape to your board. Prepare your colours as shown on page 22. The highlight along the shoulder of the apple will be taken back to the white paper with a clean damp brush once the first yellow layer has gone down. This apple study is an exercise in wet in wet, adding paint in wet, to almost dry. There is always some uncertainty when working wet in wet. You may have to try this a few times before you get it right.

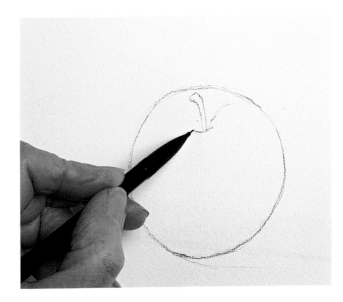

1 The under-drawing, in this case a simple outline, is finished off.

2 A first wash of yellow, a mixture of Lemon Yellow and Quinacridone Gold, covers the apple. Keep the board at an angle so that the paint drops downwards. Before it dries too much, add a mixture of Quinacridone Gold and a touch of Alizarin Crimson to the lower two thirds. It will merge with the yellow. If the paint gathers in a pool at the bottom of the apple, take it off by gently touching it with a clean damp brush (see page 33).

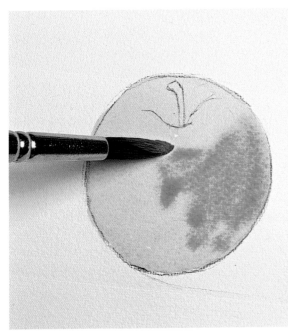

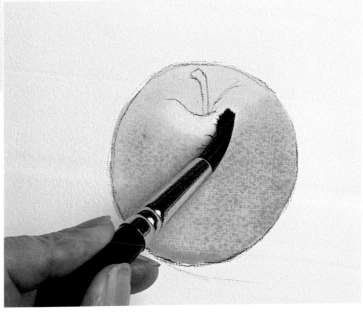

3 The apple has a soft-edged highlight that should be removed with a clean, damp brush. Touch down with the side of the brush, not the tip, and lift off cleanly. Because the paint is wet, it may creep back so you might have to repeat this a few times. Watch it closely while it dries.

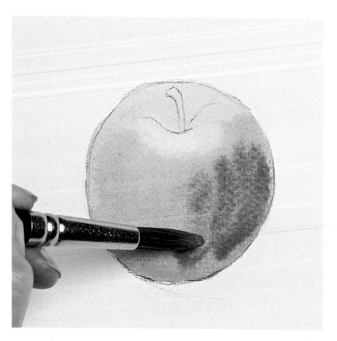

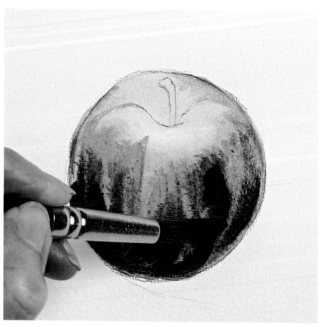

4 Do not let the paint dry completely as the next layer needs to go on once the paint has started to lose its shine but remains wet. This layer of Quinacridone Gold and a little more Alizarin Crimson is painted onto the lower part of the apple. The colour will bleed into the yellow creating a soft transition between the two colours.

5 Wait until the paint becomes damp, before you add pure Alizarin. The brushstrokes will merge with the layer below but will be visible. It looks rather dark when it first goes on but it will dry paler. Use the linear markings on the apple to help describe its round shape.

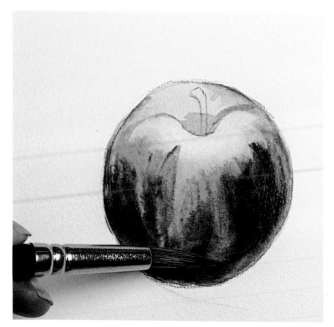

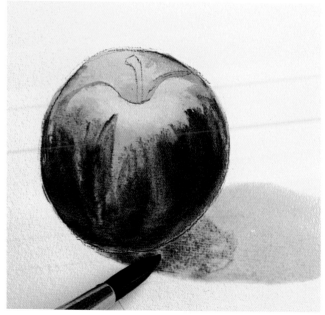

6 When the stalk end of the apple is dry, mark out the shadows with dilute Dioxazine Violet. Take stronger Dioxazine Violet to build up the shadows on the base of the apple.

7 For the shadow on the table, paint the area first with water. Touch in a little Dioxazine Violet and encourage it to spread over the pre-wetted area. Now take your brush and bring a little of the apple colour from the base of the apple into the shadow and allow them to merge.

8 Build up the richer tones at the darkest points, where the apple meets its shadow, with a touch more Dioxazine Violet.

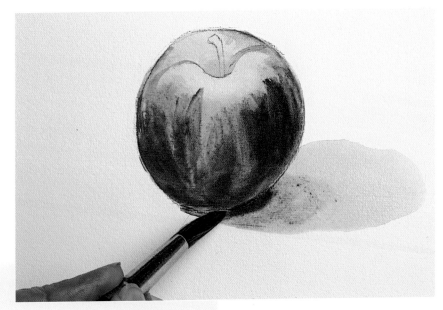

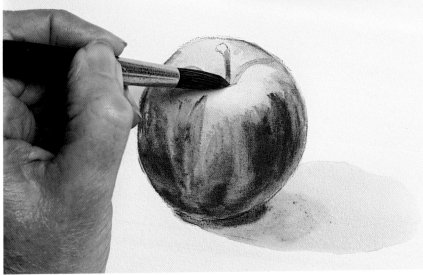

9 Carefully paint in the stalk with a dry mix of Quinacridone Gold and Dioxazine Violet. Do not paint it too solidly as the light will play on the texture and shape of the stalk. Blot it with a tissue if it looks too rigid.

The finished apple is good enough to eat. The area of shadow and deeper tone on the apple has been built up successfully wet in wet with pure colour to achieve a vibrant result.

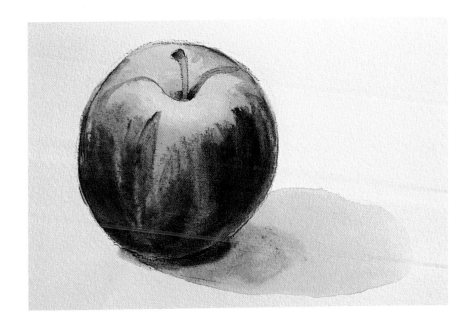

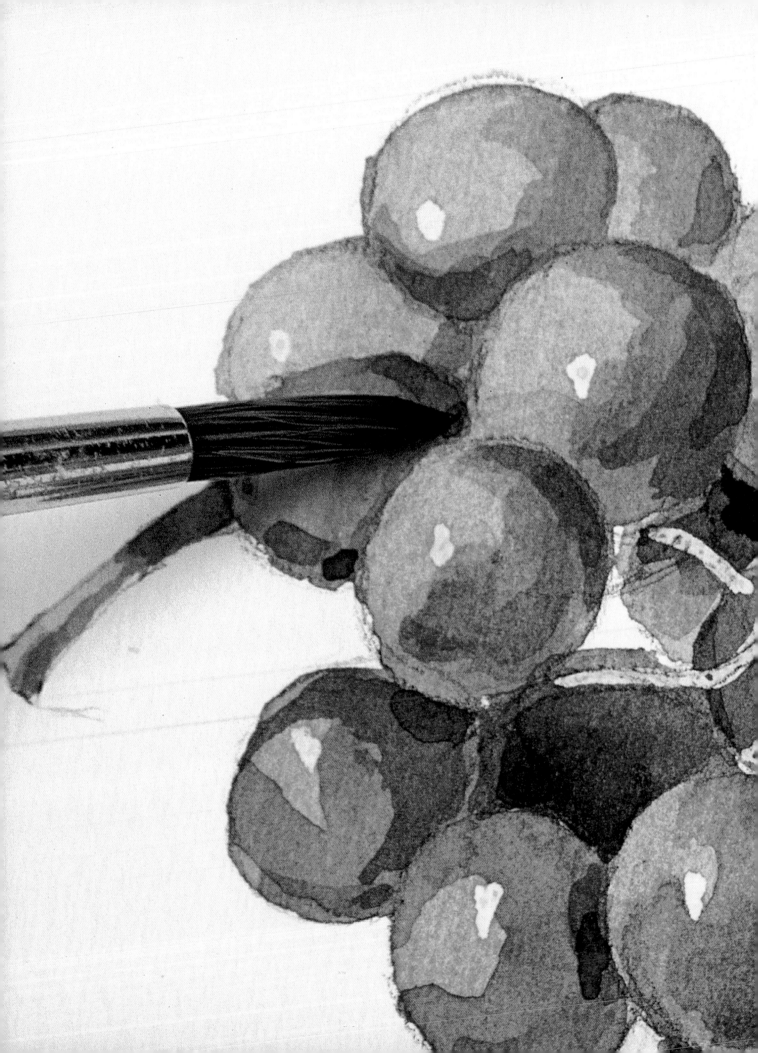

Step 3
tone

focus: bunch of grapes

Materials

Paper for sketching

Watercolour paper, 300 gsm/140 lb

Masking fluid

HB clutch pencil

Round brush, size 6

Clean damp brush

Old brush to apply masking fluid

Tissue/kitchen paper

Watercolours:

• *Quinacridone Gold*

• *Phthalocyanine Blue*

• *Cobalt Blue*

• *Brown Madder*

• *Dioxazine Violet*

Watercolour is a transparent medium that requires several layers of colour to build up depth and tone. Before you start a watercolour painting you need to assess the different tones – a tonal sketch will help – and as you start, leave the highlights and lighter parts of the painting free of paint, or covered with pale washes; then you build up the darker tones and shadows with successive layers of paint. This method is known as working from light to dark. With opaque mediums, like oil paint, you work the other way around, starting with the darks and adding the highlights last.

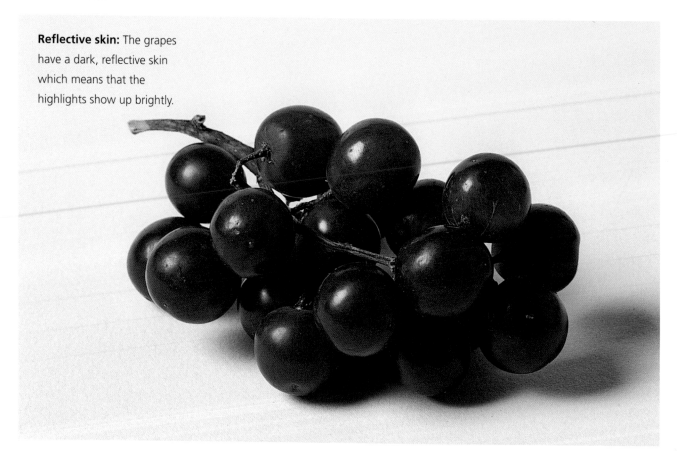

Reflective skin: The grapes have a dark, reflective skin which means that the highlights show up brightly.

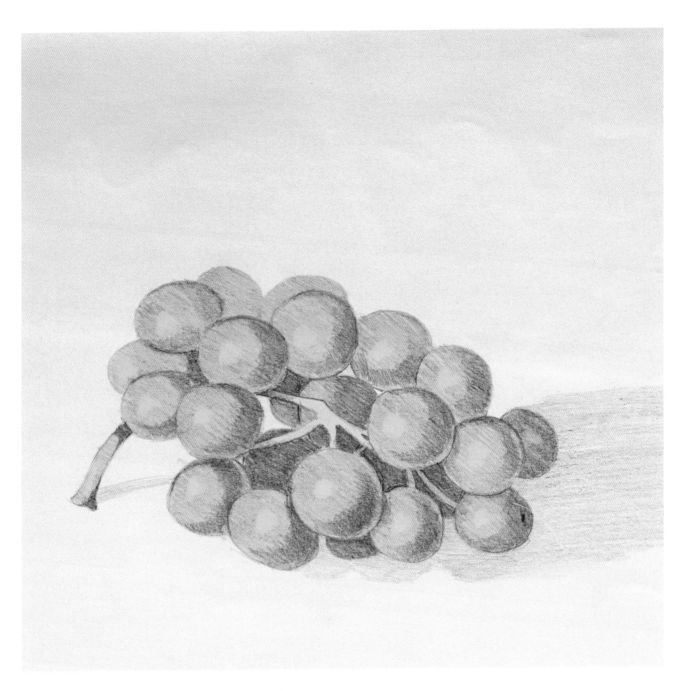

TONAL SKETCH

The watercolour painter's first job before painting is to locate the highlights. A tonal sketch can help you locate the highlights, mid-tones and shadows, which will help you to plan your painting.

Pick a small bunch of grapes and look at the individual grapes. Simplify the range of tones into three areas: the highlights, the mid-tones and the deepest shadow. A black and white photocopy of a colour photograph will simplify the tonal spread and will help you to see the distribution of tone.

Look at the form of the bunch – its shape. It has a front, back and sides. Consider this when planning your composition. Introducing a shadow cast by the bunch of grapes on the table helps to place it on a surface, giving it shape and volume.

Direction of light

It is important when planning a painting to work out where the light is coming from and to make the highlights and shadows fit in with this. For this bunch of grapes, the light is coming from the left, behind the artist. It is useful to indicate this with an arrow on your sketch so that you remember it as you draw. The highlights on the grapes are all in the same place, a small dot of light. Because the light is coming from the left, a shadow is cast on the white table surface to the right and slightly behind the grapes.

The light cast is strong and the grapes have a shiny reflective skin so that the highlights are clear-edged and bright. The highlight on the apple in **Step 2 preparatory drawing and sketching** was softer, as the light was not as strong and the skin of the apple not as reflective. This information will help you decide how you will create the highlights. For the apple, the highlight was lifted off once the first wash had been laid down for a softer effect. For the grapes, the highlights will be reserved from the outset with masking fluid (see below), which produces a hard-edged patch of white paper.

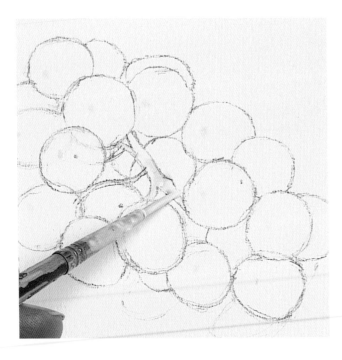

Masking fluid

It is very easy to paint over highlights once you get into the spirit of your painting, especially if there are as many as with these grapes. It is a good idea to reserve them with masking fluid, a rubbery liquid applied with a brush that you paint onto the highlights or any small details such as the stalk, which might otherwise get lost. The fluid dries and is impervious to paint. At any point, as long as the surrounding paint is dry, you can remove the mask with a putty eraser (or a clean finger).

Applying: Use an old paint brush to apply masking fluid as it will ruin a good one. Masking fluid has to be applied rather than painted on; it does not run free. Make sure it has dried before you start painting.

Interstices

Note how the distribution of tone on a grape is affected by its neighbours; there is a shadow where the grapes touch. Take care to describe the shapes between the grapes – known as interstices. In the painting (right) you can see that adding the shapes between the grapes has given a three-dimensional effect.

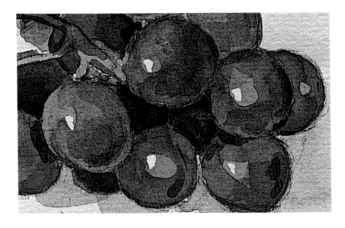

Translating tone into colour

Avoid making a colour darker by adding black. You can create areas of darker tone by superimposing layers of the same mixture of paint or combining the three primaries. You will see from the finished painted sketch on page 51 that the grapes are built up not by adding grey and black for the shadows but by adding reds, browns and purples. The mix sometimes leans more towards the reddish Brown Madder and sometimes the bluer Dioxazine Violet. This means that the final painting is filled with light and colour and is not dull and lifeless.

The build up of colour and tone follows the simplified tonal sketch on page 47, with only three layers of paint describing the pale, mid-tone and dark areas. You will notice also that the grapes are not painted a uniform colour; they are warmer and redder at the front, bluer and cooler at the back. This effect is explained in more detail in **Step 6 lost and found edges**.

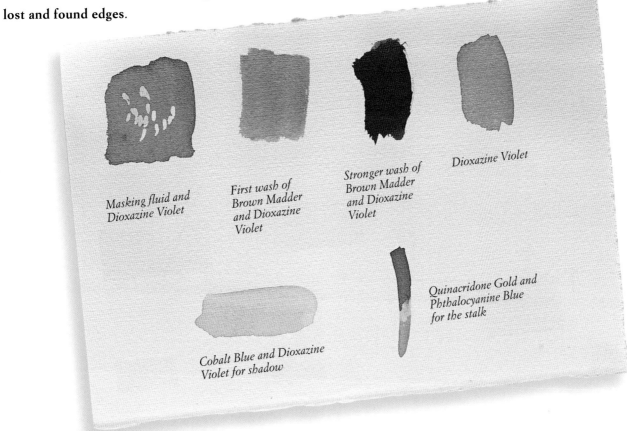

Masking fluid and Dioxazine Violet

First wash of Brown Madder and Dioxazine Violet

Stronger wash of Brown Madder and Dioxazine Violet

Dioxazine Violet

Cobalt Blue and Dioxazine Violet for shadow

Quinacridone Gold and Phthalocyanine Blue for the stalk

Trials: Try out ideas for your painting on a spare piece of good paper: mixes, techniques, and any problem areas.

PREPARING TO PAINT

The mixes of paint used for the grapes are Brown Madder and Dioxazine Violet in a dilute wash for the pale areas, plain Dioxazine Violet for the next wash and finally a stronger mix of Madder Brown and Dioxazine Violet for the darker areas. The increase in tone comes from a build up of washes rather than an increase in the strength of the paint. The stalk is a mix of Quinacridone Gold and Phthalocyanine Blue and the shadow Cobalt Blue and Dioxazine Violet.

PAINTING THE BUNCH OF GRAPES

Reserving the highlights with masking fluid will allow you to concentrate on the slight challenge that painting these grapes entails.

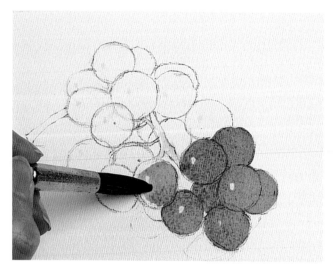

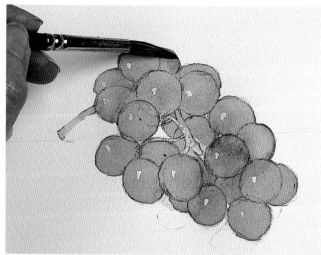

1 The first warm reddish wash goes on the foreground grapes (paint over the masking fluid). Make your brush do the work. You will find it will fill in each grape, describing the round form, with little effort from you. The less you work the paper, the better the results will be. Practise on a spare piece of paper first.

2 In this first wash, be aware of the form of the bunch of grapes, rather than the individual grapes. Paint the grapes at the back bluer and cooler, which pushes them back. See how this first wash varies in colour and tone. You are not aiming for a consistent flat wash. A pale wash of Quinacridone Gold and Phthalocyanine Blue defines the stalk.

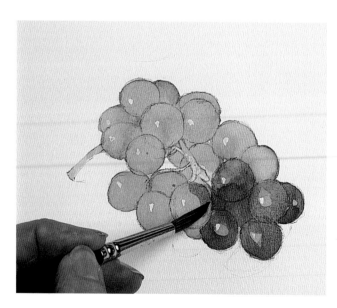

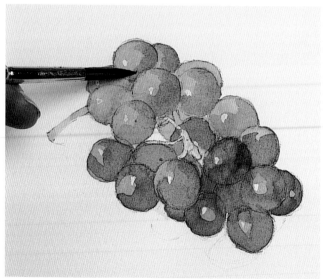

3 When the first wash is dry, add the second. Note how this second wash does not cover the whole grape but leaves an area of the pale wash visible around the highlight and to one side. The curved paint strokes of this mid-tone shadow start to build the spherical form of the grapes.

4 Build up the grapes at the back with the same mix of paint. Encourage the paint to go on unevenly, suggesting differences in the shapes of the grapes and the reflected light around them. This variation will greatly energize your painting. Allow to dry.

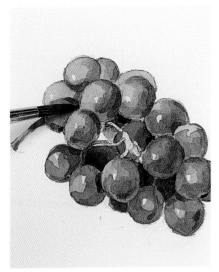
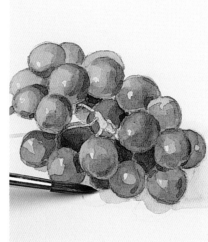
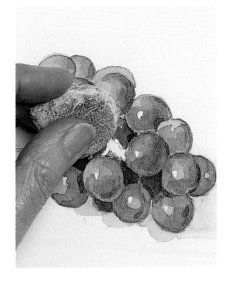

5 With a browner mix, paint in the touches of darker shadow on the grapes and stalks, particularly where they touch one another. With an eye to balancing the tones, the patches of this darkest purple should match the areas of whitest highlight. Paint over the interstices to make them darker. This throws the picture into relief, pushing the grapes forward and allowing the eye to go deep into the bunch.

6 A pale wash of Cobalt and Dioxazine Violet is used to paint the shadow the grapes cast on the white surface of the table. Allow it to peter out at the edges.

7 Once the painting is quite dry (test carefully), use a putty eraser or specially cleaned finger to rub off the masking fluid.

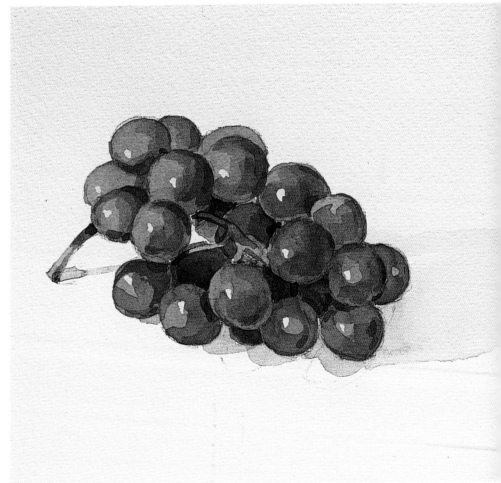

Finishing touches are added. The newly uncovered stalk in the centre of the bunch can be painted, bringing it up to the same tone as the surrounding grapes but preserving its integrity. The shadow cast by the main stalk on the table is traced in the same mix as the rest of the shadow. The painting is finished. Stand back and admire your masterpiece.

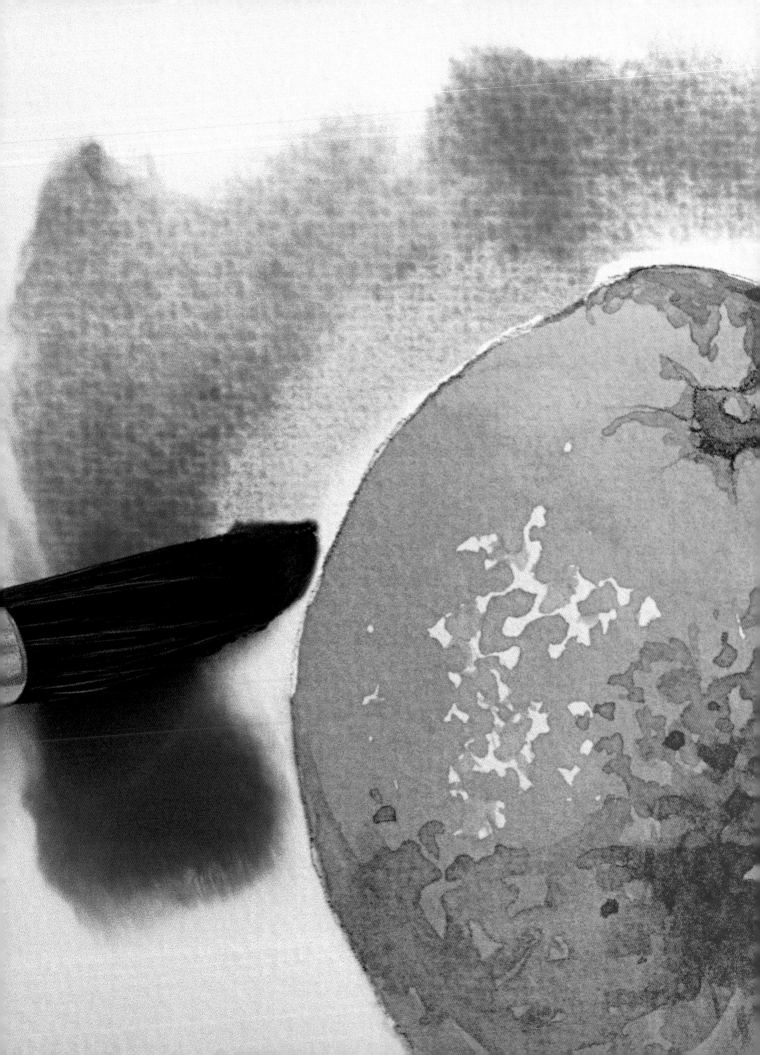

Step 4
watercolour layers

focus: orange

Materials

Paper for sketching

Watercolour paper, 300 gsm/140 lb

HB clutch pencil

Round brush, size 6

Clean brush

Tissue/kitchen paper

Watercolours:

• *Cobalt Blue*

• *Phthalocyanine Blue*

• *Phthalocyanine Red*

• *Quinacridone Gold*

• *Payne's Gray*

A good watercolour painting is usually built up in a number of layers of superimposed colour working from light to dark. This means that the first layers comprise pale, dilute washes of colour, mapping out the painting. Successive layers can be added while the paint is still wet or damp (wet in wet), or once the first layer is dry (wet on dry). The gradual build up of paint helps to create texture, three-dimensional form, and depth of colour and tone, which cannot be achieved in the same way with just one layer.

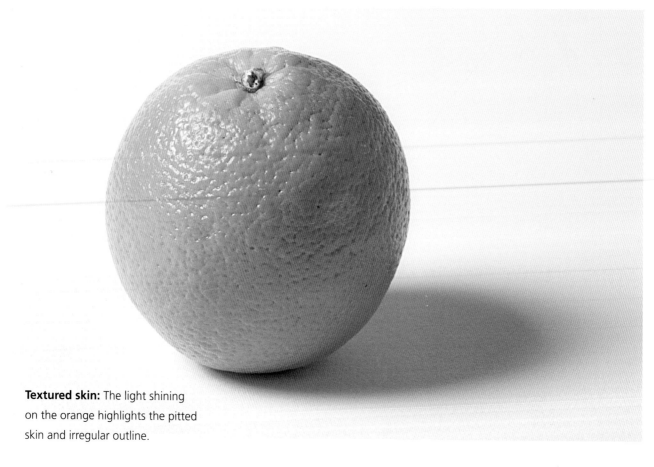

Textured skin: The light shining on the orange highlights the pitted skin and irregular outline.

BUILDING TONE IN LAYERS

You can build up tone in layers by simply adding successive layers of the same dilution of paint. Building up tone gradually in this way allows you to go carefully and can stop you from painting an area of tone that is too extreme. This happens all the time and first dabs are always tentative.

Grey layers

To help with the idea of building up watercolour layers, try it out first with some patches on a piece of spare paper. Build up three tones of grey, from light to dark, with superimposed washes of dilute Payne's Gray – a blue-grey that comes ready mixed.

Patches: First paint your pale grey on three patches across the page. Once dry add another layer of the same mix to patches 2 and 3. Allow to dry and add a third layer to patch 3. Your results will be as shown here.

First aid

If you can see that the first dabs are too dark, don't panic. You can take them back by drying off your brush, then touch down onto the wet paint and the paint will come back up into the brush. If the layer is dry underneath, blot gently with a tissue.

PREPARATORY STUDY

Use this technique to explore the tonal range of the orange, from light to dark, building it up in layers. (See Step 3). The highlights will be the white of the paper; the first layer of paint will be the pale mid-tones; the second layer the dark mid-tones; the third layer the dark tones.

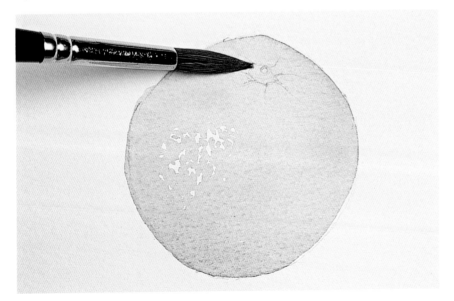

1 Sketch the outline of the orange and then paint in the first layer of pale grey, leaving dots of white paper where the light catches the texture of the skin. The result resembles an orange but it needs to look more three-dimensional. Allow to dry.

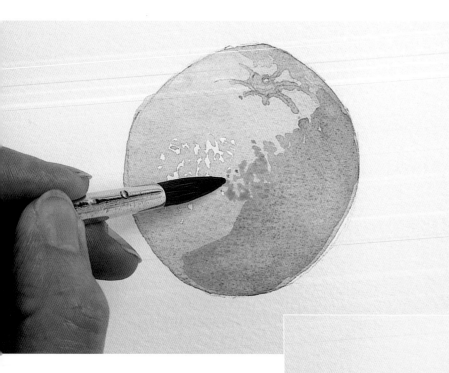

2 Build up the darker mid-tone areas with a second layer of the same grey mix, avoiding the pale areas where the light touches the orange. Do not forget the shadows at the top in the creases and on the stalk end. It will look dark but will dry paler. Make the edge between the greys uneven to hint at the texture.

3 Finally, add another layer of tone in the area of the darkest shadow at the front and side of the orange and on the stalk end, stippling it on for a textured effect.

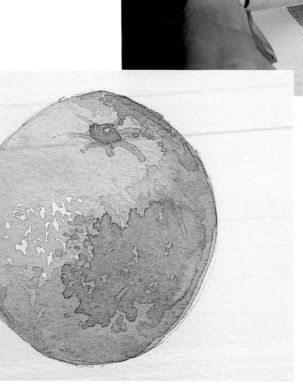

You can see how the tone and three-dimensional form has developed from the build up of layers.

PREPARING TO PAINT

In **Step 1 exploring colour** we saw how colours can be mixed on the palette and by superimposed layers on the paper. Let us look at how a combination of these techniques work for this orange by trying out some colour combinations built up in layers.

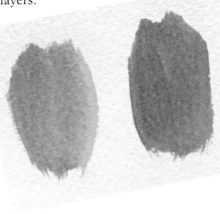

Colour choice: Mix three tones of orange, from paler orange-yellow to darker red-orange – variations of Quinacridone Gold with Phthalocyanine Red.

Building up texture: Practise by stippling the three shades of orange onto a piece of paper, superimposing one layer with another so that the colours shine through, building up the pitted texture of the skin.

Delicate details: Use the very tip of the brush to paint in the characteristic stalk end using a mix of Quinacridone Gold with a minute touch of Cobalt Blue. Even with a big brush, delicate details are possible with the springy tip. With a small area, take off most of the paint on your brush, even dabbing it on a tissue, or you will swamp the area with wet paint.

Dropping paint into a wet area: One way of controlling the spread of a wash is to wet the area with a clean brush and water and then drop the colour in. The colour spreads out in an alarming manner covering only the area you have wetted. You can do this over dried layers of paint or around a finished painting (see **Step 9 creating drama**). Work with the paper flat. Allow the water to be absorbed by the paper before adding the blue colour and leave it to spread without disturbing it. It will dry as you can see here, flat but with a characteristic edge.

PAINTING THE ORANGE

You now need to pull together everything you have learnt to paint the orange, built up in layers of watercolour. Start by drawing the orange as described in **Step 2 preparatory drawing and sketching**. Then mix enough of the three shades of orange for the painting.

1 Load your brush with the orange-yellow mix, and start with the highlight area, which is applied with a stippling stroke with the tip of the brush. This will suggest the texture of the orange. Then let the brush do the work, taking the paint around the curved edge of the orange, pressing gently into it so the hairs bend.

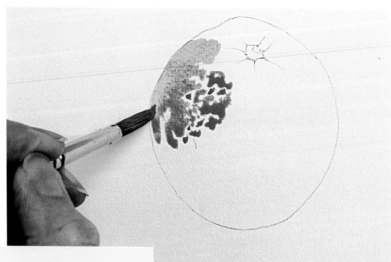

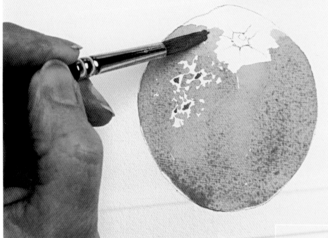

2 Carefully take the paint around over the rest of the orange in a smooth layer. When the orange is quite covered except for the stippled highlights, allow the paint to dry.

3 With the redder wash stipple on the paint in the shadow area. Work it into the folds of the skin around the stalk end at the top, and over the right-hand side of the orange, using the stippling motion that visually blends this layer into the first one. Allow to dry.

4 Add the even deeper glow of reddish orange that comes out in the shadow area with stippled touches of the transparent, more intense, redder mix, building up the tone. The tone in the shadow area is intensified through a build up of colour. Allow to dry.

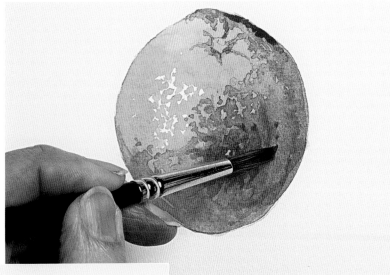

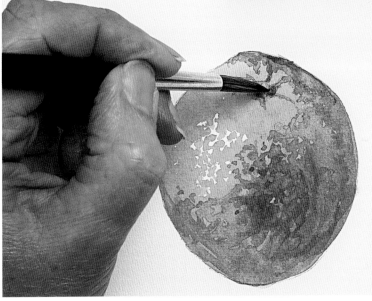

5 Now with the tip of the brush and a touch of the dry greenish mix, carefully fill in the stalk end.

Once the orange is dry, complement it with a background wash. Lay the painting flat and wet the area around the orange with clean water applied with a clean brush. Once the water has been absorbed by the paper and no longer glistens, touch in the blue around the orange desisting from painting it in. It will spread dramatically without any help, finally drying to a smooth blue.

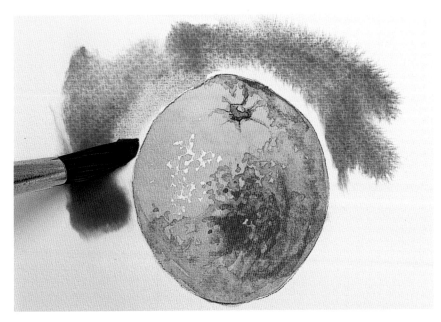

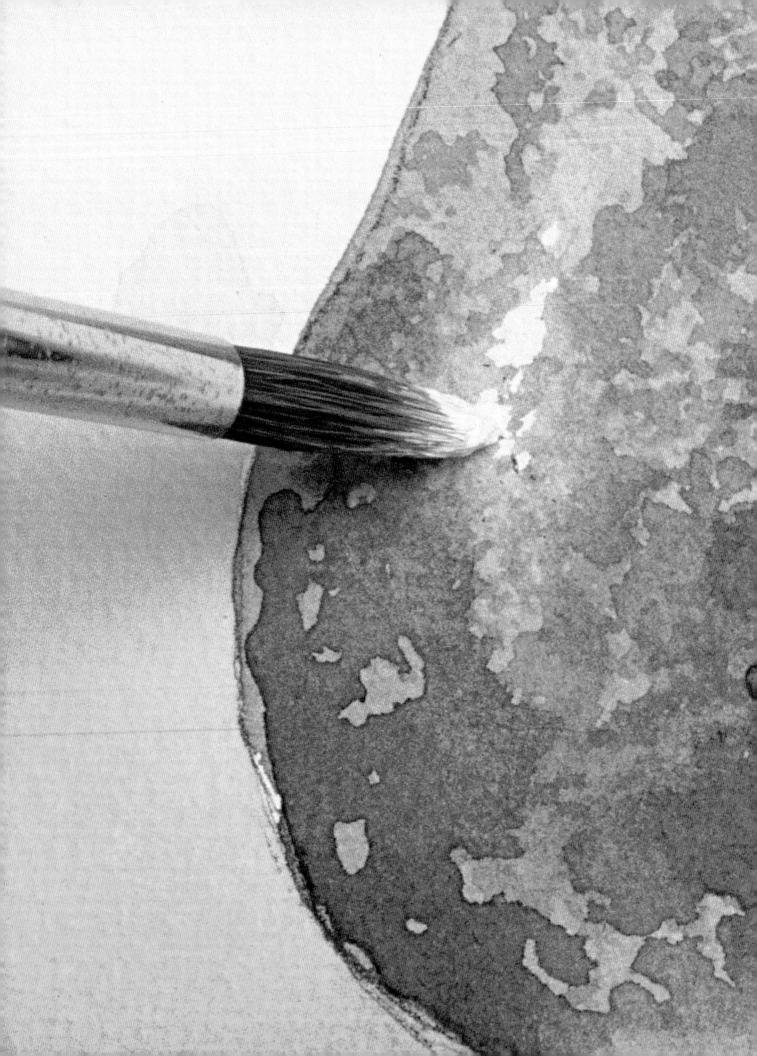

Step 5
texture

focus: pear

Materials

Paper for sketching

Watercolour paper, 300 gsm/140 lb

HB clutch pencil

Round brushes, sizes 6 and 12

Flat hog-hair brush

Sponge

Tissue/kitchen paper

Watercolours:

- *Quinacridone Gold*
- *Lemon Yellow*
- *Phthalocyanine Blue*
- *Dioxazine Violet*
- *White gouache*

Painting in flat measured strokes can lead to some dull results. Here we look at some inventive techniques to create different textural effects, such as dry brush for mottled effects and spattering for patterns of light. The eye needs to be entertained as it travels around your painting and textural techniques help to inform and, at the same time, add variation to the brushstroke. In this simple painting of a pear, the aim, apart from celebrating its perfect shape, is to show off its attractive russet skin. It is an ideal vehicle for practising textural techniques.

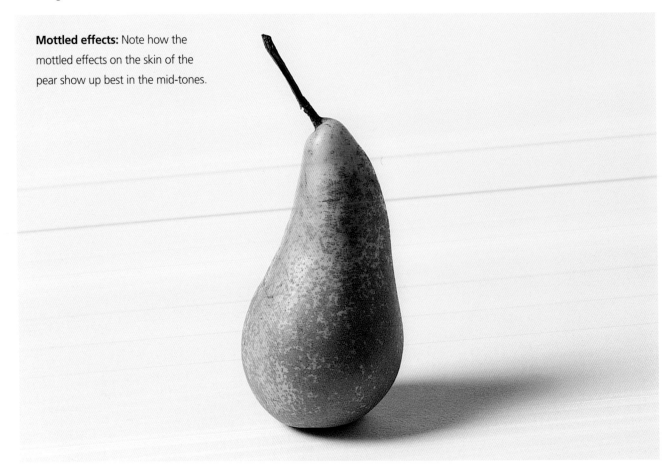

Mottled effects: Note how the mottled effects on the skin of the pear show up best in the mid-tones.

LAYERS OF TEXTURE

As you are probably beginning to realize, painting in watercolour is a juggling act. You are always doing a number of things at the same time. This also applies to building up layers of texture. As you build up texture, you are also building up tone, modelling form and mixing colour optically. Whatever one's intentions, it is hard to think of all these things at the same time. Luckily, most of them come together without too much effort.

Building up tone with texture

With successive layers of sponging and stippling, you are using the build up of texture to build up the tonal values in the same way as seen in **Step 3 tone**: first, a pale wash, second, a mid-tone wash, third, the darker shadows. A tonal sketch is useful to establish the distribution of light and shade on your pear before you start and will help you to decide where exactly you place the textural marks.

Modelling with textural marks

You will also be modelling your pear with the textural marks, building them up in the shadows and sponging and stippling more sparsely where the light falls.

Idea swatches: When you try out your ideas, make a series of patches, allowing them to dry, so that you can try out a number of ideas. Try adding sponge marks to a damp first layer so that the marks are less defined.

Mixing colour through broken techniques

As we saw on page 34, colour can be mixed optically by superimposing layers of paint and it is particularly effective when the second layer is broken in textural marks. With this pear, the colours are all within the same range, but the build up of textural marks creates the deep russet green.

Which technique?

In painting, there are always a number of ways of arriving at the same outcome. How you decide to create a certain effect will depend on the area that needs to be covered. A smaller area than this pear might have suggested dry brushing or stippling. You can always try out some ideas before you start.

You do need to be careful, however. What is important about this pear is that, although the texture of the skin is created with sponging and stippling, the crisp, hard outline is necessary to describe the nature of the pear and must be carefully preserved. If you allowed the texture to spread over the boundary of the pear, it would make it appear soft and woolly. Sponging the whole of the pear could be risky as you approach the edges, as a sponge is a little difficult to control. Combining it with a layer of stippling makes it possible to cover the area effectively, using the stippling close to the edge of the pear.

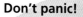

Don't panic!
If you do go over the edge of your pear, let the paint dry then very carefully, with a clean damp brush, work at the paint until it comes away. Blot with tissue.

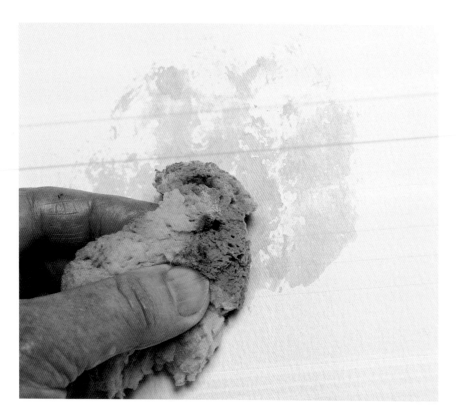

Sponging: A small piece of natural sponge is ideal – it will be more expensive to start with but will last forever. Dip it into the paint and press down lightly, lifting off cleanly.

Stippling: Over a dry layer of Quinacridone Gold and Phthalocyanine Blue, try out the stippling stroke using the tip of the brush. If the paint is too wet, the stipple loses its identity.

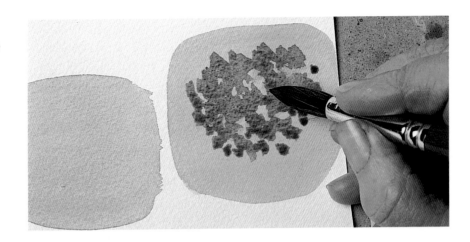

PREPARING TO PAINT

The glorious green-gold of the first layer is a mix of Quinacridone Gold and Phthalocyanine Blue. The sponging mix leans more towards the blue and has Dioxazine Violet added for the darker stippled layer. There has to be a contrast in tone between the layers or the technique will not work. For the stalk, add more violet. Start with the cool Lemon Yellow for the background and come down to warmer Quinacridone Gold. A glaze of violet works for the shadow.

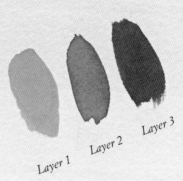

Sponge

Dryish brush

Layer 1 *Layer 2* *Layer 3*

More trials: Dry brush is an option too. Here we have tried out sponging, top left, and dry brush, top right, to compare them. The sponging suits the markings on the pear better. Opposite are the three intended layers, from the left: Quinacridone Gold with a touch of Phthalocyanine Blue (layer 1); with added blue (layer 2); with added Dioxazine Violet (layer 3).

PAINTING THE PEAR

The juggling act begins. Keep it simple and do not allow yourself to be sidetracked by too much detail. Note the direction of the light and the soft highlights down the side, which you will lift off at various stages.

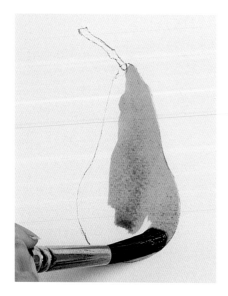

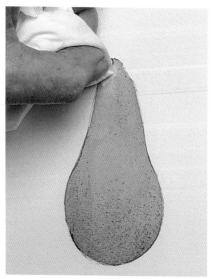

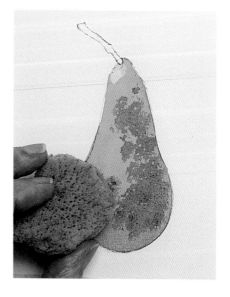

1 Start with a strong wash of Quinacridone Gold with a touch of Phthalocyanine Blue. Lay the wash on in as few clear strokes as possible. Do not worry if the wash looks a bit uneven; it will flatten out as it dries and it will have the textural marks superimposed on top.

2 Before the wash dries, lift off a soft-edged highlight from the top of the pear with a tissue. Work the tissue into the shape that you want – here a rather small delicate ellipse.

3 Allow the first wash to dry (or speed it up with a hairdryer) and then take a sponge and dip it into the same mix with a little more blue. Delicately sponge the pear making sure enough of the lighter first wash shows through.

Don't panic!

If your first wash is not strong enough, allow it to dry and add another over the top.

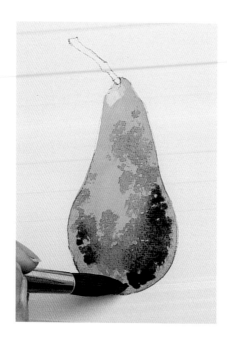

4 Allow to dry then, with a darker mix with violet added, stipple over the sponged area, building up the texture and tone. See how an area has been left paler near the bottom edge of the pear where you might expect the darkest shadow. This pale area is there in reality. It is important in describing the shape of the pear. Keep looking at your real pear or the photograph to see these variations in tone. The stippling adds to the interesting pattern of the pear skin.

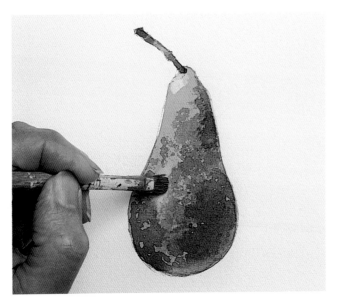

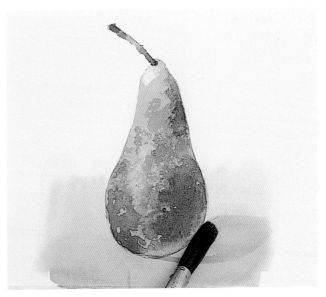

5 Lift off the highlight describing the curve of the rounded base of the pear with a coarse hog-hair brush. Make sure the brush is clean and dried off on a tissue. Go carefully, as you do not want the highlight too white; you only want to go down to the first wash. Paint in the stalk with a little more violet added to the green mix. Blot it with a tissue to make sure the colour is not too consistent. Allow to dry.

6 A yellow graduated wash goes in for the background (see page 94). Start with a dilute wash of cool Lemon Yellow, and add a stronger warmer mix of Quinacridone Gold as you go down the page. Once this wash is dry, add the shadow of the pear – a simple violet glaze (see page 34) over the yellow.

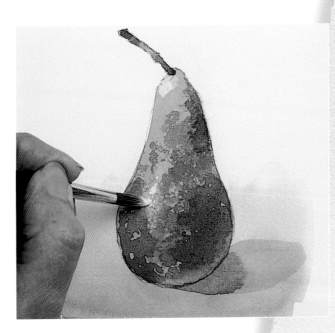

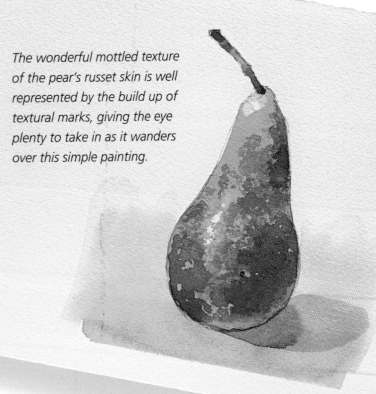

The wonderful mottled texture of the pear's russet skin is well represented by the build up of textural marks, giving the eye plenty to take in as it wanders over this simple painting.

7 A second violet wash is added wet on damp closer to the pear, slightly straying over into the pear to darken the edge. The artist decides that the highlight is not bright enough. A few touches of white gouache add the sparkle required. Smudge it with your finger if it looks too bright.

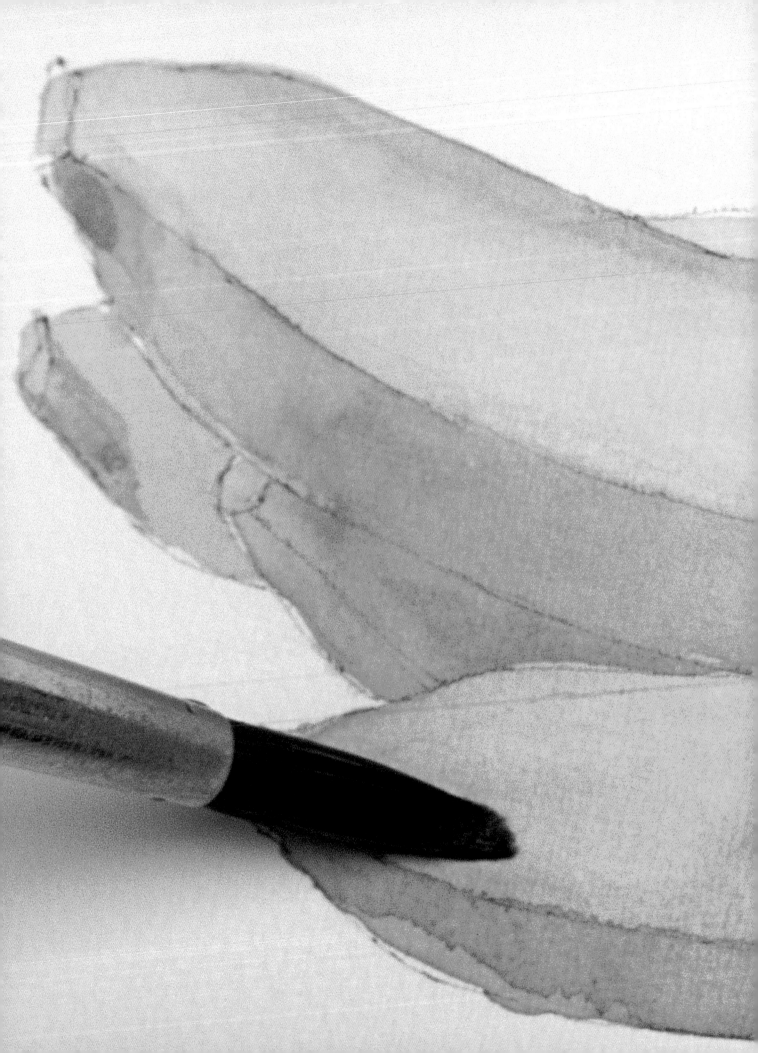

Step 6
lost and
found edges

focus: bananas

Materials

Paper for sketching

Watercolour paper, 300 gsm/140 lb

HB clutch pencil

Round brush, size 12

Flat hog-hair brush

Tissue/kitchen paper

Watercolours:

• *Lemon Yellow*

• *Quinacridone Gold*

• *Phthalocyanine Blue*

• *Dioxazine Violet*

In this step, you will be taking a huge leap towards emerging as a watercolour artist by considering lost and found edges. By edges, we mean where one thing ends and another begins: the boundary of an object. If you were to paint a solid, no-nonsense line around each banana in the painting it would look simplistic; this is not how nature behaves. Distortions of light, reflected colours, variations in the shape of the bananas mean that the edge comes into focus and disappears as it is seen against variations in colour and tone beyond. The artist therefore needs guile in setting about 'finding' and 'losing' edges. Success will give your painting subtlety and the look of experience.

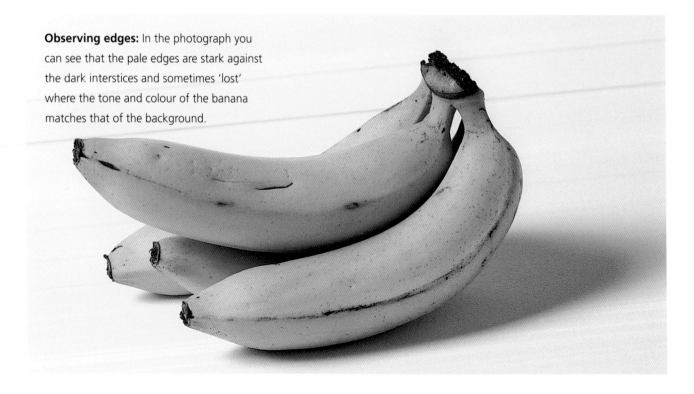

Observing edges: In the photograph you can see that the pale edges are stark against the dark interstices and sometimes 'lost' where the tone and colour of the banana matches that of the background.

COLOUR CONTRASTS

Edges are easily made to stand out if there are contrasts of colour. This would be straightforward if one banana was yellow and the other blue but subtle differences in colour work just as well. You will see how the artist starts with a cool blue-yellow for the banana at the back and uses the warmer yellow for the front ones. This creates a sense of recession, but it also separates the bananas. You can employ this technique for one object of many, as for this bunch of bananas, or simply within the variations of a wash along an edge.

Tonal contrasts

You can find an edge by contrasts in tone: by placing a pale object against a darker one, or vice versa. If the banana is the positive shape and the colour beyond the negative shape, this can mean building up the negative shape by increasing the tone or colour there so that the edge of the positive shape stands out. You can see how the edge of the banana is found in Step 8 of the painting on page 75.

Just as you can build up the tone in the negative shape, you can also reduce the tone and increase the contrast in the positive shape by taking back the paint and making it lighter along the edge. You can foresee this and leave a lighter area as you apply your washes or you can lift off with a damp brush or tissue as in Step 6 of the painting on page 74.

Shadows

Shadows give you a good excuse to provide contrast and bring out an edge. Not only cast shadows as you can see in Step 9 on page 75, but also in shadows that describe the form. The middle banana is given a shaded edge where it curves away across the top and, coincidentally and conveniently, where it is seen against the white background. The yellow edge of the banana might otherwise be lost. The convenient markings of the banana along the edges also help here.

This area of dark and light is balanced with a similar area at the other end of the bunch, where a chink of light seen through the stalks is contrasted with shadows built up on the bananas.

Slither of light

An artful trick is to 'find' an edge with a slither of light. This is where a suggestion of a highlight along an edge describes it graphically as with a white line. This needs to be subtle and indeed, in the finished painting on page 75, it is so subtle that you could easily miss it. Nevertheless, it is essential to the eventual success of the painting. Even in the first wash, halfway along the top of the foreground banana, a slither of white paper is left unpainted. This is intentional and you can see that this slither of light is preserved through further washes. Then when the darker markings on the banana are added, you may think it has been painted out but it is still there, subtly highlighting the edge of the foreground banana. Such a slither of light can be added at the end by scratching out with a blade (see page 83).

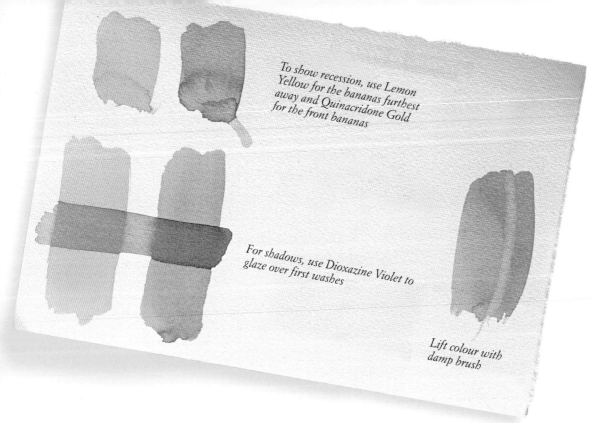

To show recession, use Lemon Yellow for the bananas furthest away and Quinacridone Gold for the front bananas

For shadows, use Dioxazine Violet to glaze over first washes

Lift colour with damp brush

PREPARING TO PAINT

You will need a warm and cool yellow for the initial washes. Look hard to see the variations in colour; it will greatly add to the liveliness of your painting. The pale green tips of the bananas will come from the addition of a touch of Phthalocyanine Blue to the Lemon Yellow. The lovely shadow glaze is pure, rich, transparent Dioxazine Violet and the darker markings and shadow are violet and yellow, too. Keep the wash leaning well towards the violet as it is going in over the yellow.

Shadow glazes

The shadows on the bananas will be glazed on with pale transparent Dioxazine Violet. Shadows made with the complementary colour always work best (here yellow and violet). Allow the first washes to dry before applying the shadow glaze. Make sure you apply it cleanly as, if you dab rather than wash the colour lightly over the area, you will disturb the wash below.

Lifting off thin highlight: We have lifted off before (see page 67), but with the thin clearer-edged highlight along the edge of the banana, you will need to allow the wash to dry first. Then with a flat hog-hair brush, clean and dried to dampness on a tissue, work your way along gently lifting the paint and dabbing it off with a tissue.

PAINTING THE BANANAS

Bananas are fun to draw because their form is expressed in clear-cut shapes. Take special care over the ends of the bananas as close observation is the key to painting convincingly and successfully.

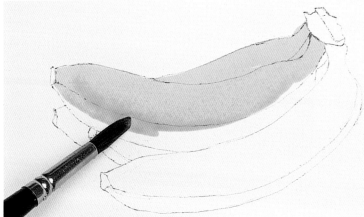

1 Start with a cool wash of Lemon Yellow over the two background bananas, add Quinacridone Gold for the foreground one.

2 Be careful to paint within the pencil outlines and leave the slither of light between the foremost and middle-ground bananas. Note the tiny keyhole of light (white paper) near the joined ends of the bananas. Small details like this are important.

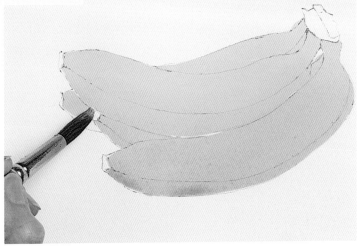

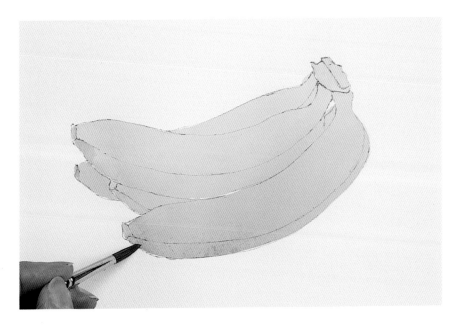

3 The tips of the bananas have a greenish lowlight to them. Add this once the initial wash has dried slightly, but is still damp so that the two colours blend. Take the green onto the joined ends. Keep looking at the bananas to see where the colour should go. Do not rely on your memory. Allow to dry.

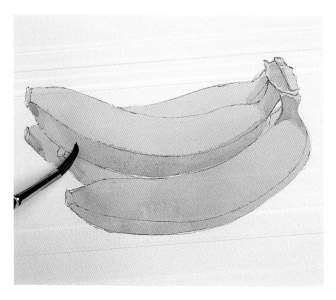

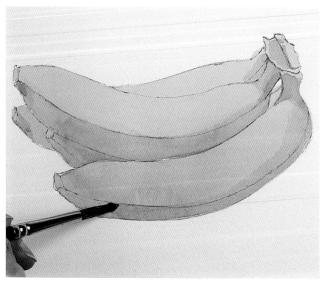

4 Test with your finger to make sure the paint is quite dry, then take a glaze of violet over the yellow in the shadow areas, starting with the stalk ends and coming down over the lower side of the middle banana. This helps to bring out the faceted shape of the banana, describing the edge dividing the banana lengthways. Be careful to conserve the slither of light between the bananas.

5 The same glaze comes over the foreground banana. Note the angled shadow near the joined end. It is very clear on the photograph.

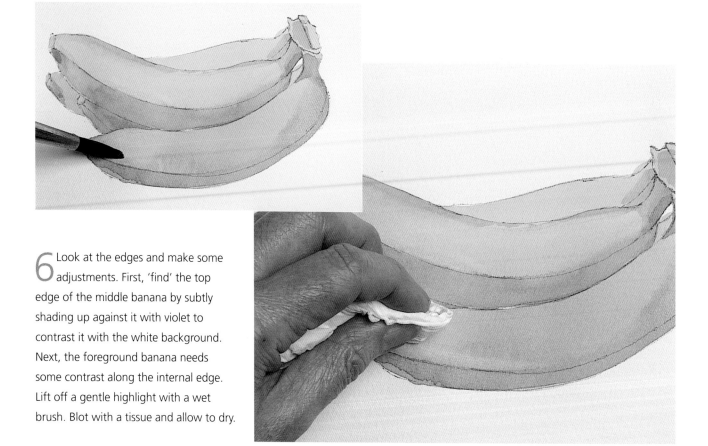

6 Look at the edges and make some adjustments. First, 'find' the top edge of the middle banana by subtly shading up against it with violet to contrast it with the white background. Next, the foreground banana needs some contrast along the internal edge. Lift off a gentle highlight with a wet brush. Blot with a tissue and allow to dry.

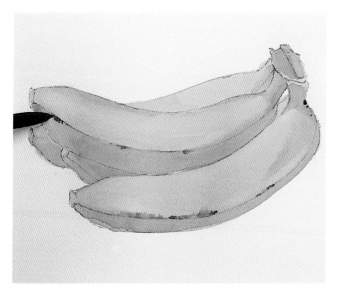

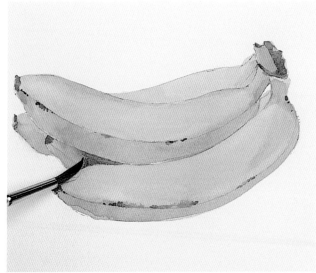

7 Finding the edges of a banana is easy because of their darkened markings. Again, look carefully, and try to imitate the irregularity of these markings. Use the very tip of your brush with dryish paint. Follow the pencil line but do not reinforce it; just add an uneven blot here and there along the line. Blot with a tissue or lift off with a clean brush if the paint looks too solid.

8 With a further violet wash, build up the tone in the space between the bananas to bring out the edges. The darks here are balanced with touches of the violet on the banana ends.

9 The shadow cast by the bananas on the white surface is painted with a violet glaze. Add the yellow-brown mix wet in wet where the shadow is darkest underneath to anchor it to the surface plane.

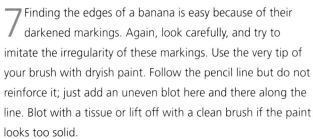

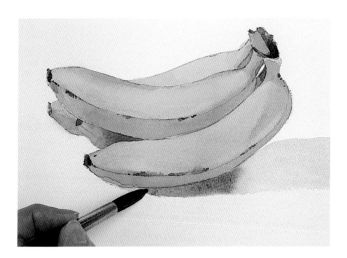

In the finished painting, you can see how the artist has gone on to make minute adjustments to make it work better: a touch here and there to balance or contrast. Run your eye along the edges and see how they have been contrived to be lost and found, coming in and out of focus – light against dark, dark against light, with patches between where the connecting edge disappears altogether. This keeps the eye moving across the painting, keeping it interested.

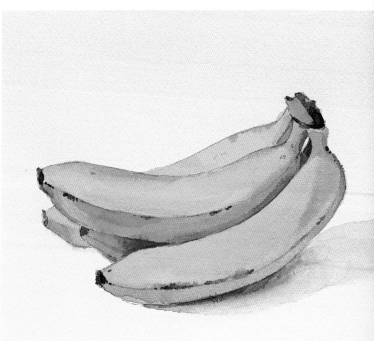

Step 7
energy and light

focus: jug

Materials

Paper for sketching

Watercolour paper, 300 gsm/140 lb

HB clutch pencil

Round brush, size 12

Clean brush

Tissue/kitchen paper

Watercolours:

• *Lemon Yellow*

• *Quinacridone Gold*

• *Phthalocyanine Red*

• *Dioxazine Violet*

• *Phthalocyanine Blue*

In photographs, subtle colours and tones are often simplified and sometimes lost; the artist's job is to put these colours back and bring in energy and light. Look carefully at any piece of white ceramic, preferably in daylight, and you will see how it picks up the delicate colour cast of the light itself and reflects the colour of surrounding objects. Like your piece of ceramic, this jug is hardly 'white' and can be described with colour rather than drab monotones. This phenomenon does not restrict itself to white ceramics; it applies to all painting.

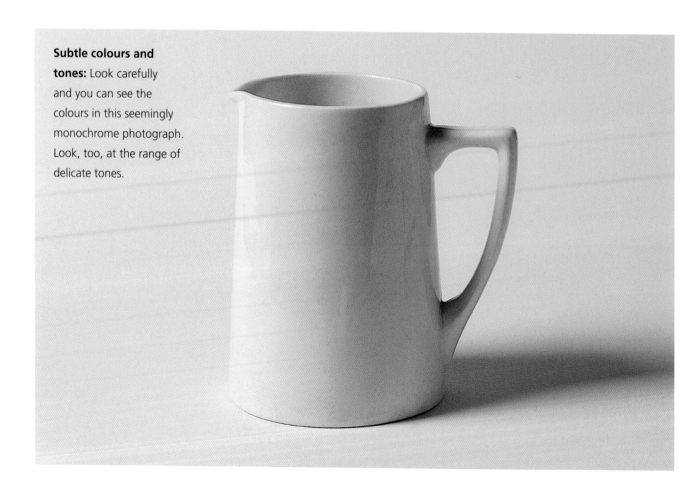

Subtle colours and tones: Look carefully and you can see the colours in this seemingly monochrome photograph. Look, too, at the range of delicate tones.

COLOUR OF LIGHT

You first have to imagine where your jug is standing. Is it in the warm golden light of a summer's day or the cool blue/yellow light of winter? Perhaps it is sitting on the window sill bathed in the warm pink glow of the evening sun or standing pale in a darkened room, lit by flickering firelight. You can decide. All these lights have a different colour cast and will influence your first washes of colour.

Energy from colour

Complementary colours (see page 31), when used in conjunction, will energize your painting. These colours do not have to be starkly placed next to each other; there are much more subtle ways of introducing them into your painting. If you start with the cast of the light, the shadows can be complementary; a yellow light will have a complementary violet shadow. For this jug, the theme continues with some play between the orange-yellow of the shadows and the cool blue background.

Reflective surfaces

The white jug is shiny and reflective. First of all this means the colour of the prevailing light will bathe it. It also means that surrounding colours will reflect off it. You can see in the photograph how the white of the table reflects off the side of the jug, creating a paler stripe of tone, breaking up the area of shadow down the right-hand side. If the jug had been sitting on a red cloth then this would be reflected in the jug. A blue sky can be seen in reflective surfaces in the countryside, in the highlights on reflective leaves, and in stretches of water.

Strong light will produce hard-edged highlights and shadows on hard shiny surfaces. Highlights and shadows will be softer-edged if the light is weaker.

Scraping back: Lost highlights can be reinstated by scraping back to the white paper with a sharp pointed scalpel. Take it gently, though you will find you need to be quite firm to have any effect. Try hard not to destroy the surface of the paper – easier said than done!

Lifting out with a tissue: This produces a soft edge and can create subtle shapes by working the tissue.

PREPARING TO PAINT

The cast of the light has been chosen as a cool Lemon Yellow with some Phthalocyanine Red added in the shadows. Layers of transparent glazes (Dioxazine Violet and Phthalocyanine Blue) build up the shadow gradually and then a cool blue background makes a pretty contrast and throws up the outline of the white jug.

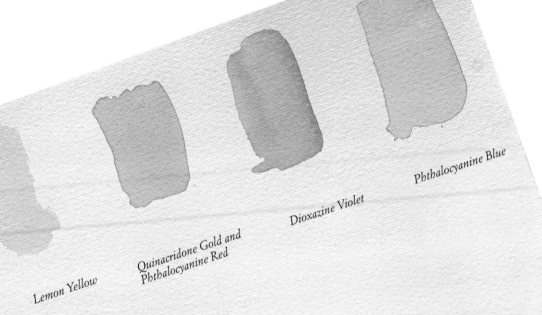

Lemon Yellow

Quinacridone Gold and Phthalocyanine Red

Dioxazine Violet

Phthalocyanine Blue

Colour trials: Trying out the colours on the paper you are going to use is helpful as paper shades vary from bright white to tones of cream and can qualify pale watercolour washes.

PAINTING THE JUG

The first yellow washes represent the warm cast of the light. These washes vary from cool blue-yellow to a warmer orange-yellow, helping to model the shape of the jug. Adding the transparent violet and blue glazes deepens the contrasts so that multitudes of subtle mid-tones develop from the variations in the yellows beneath. Look carefully before you start: the light is coming from the left, creating a soft-edged highlight down the smooth reflective surface of the jug. However, there is also reflected light from the white surface on which the jug stands, which explains the lighter area down the right side.

1 Your first dilute yellow wash is a cool Lemon Yellow. Leave the white of the paper clean for the highlights that appear inside the jug, along the top rim and on the handle.

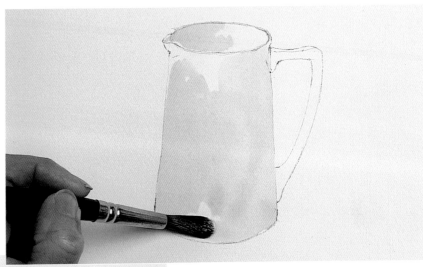

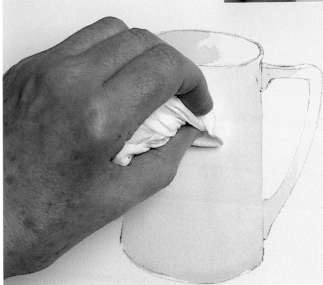

2 For the eye to believe it is a white jug, it needs to be predominantly white. Adjust the highlight down the front, lifting off the paint with a tissue. Allow to dry.

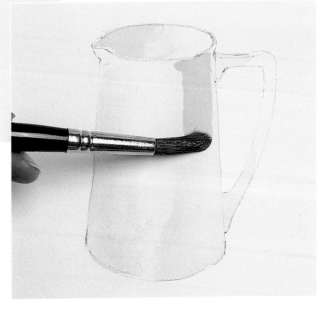

3 The second wash is a warm yellow – Quinacridone Gold with a touch of Phthalocyanine Red. Apply it over the area of darker shadow on the right, inside the jug, and also where the handle meets the main body of the jug. Note, on the far right, the band of reflected light is left uncovered.

4 The jug is hard and shiny but it is a soft light, so the edges of the highlight will need to be softened. Run a clean brush, first dried out on a tissue, down the edge. Take off paint with the side of the brush held at a low angle. Allow to dry.

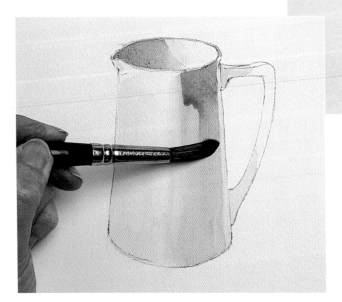

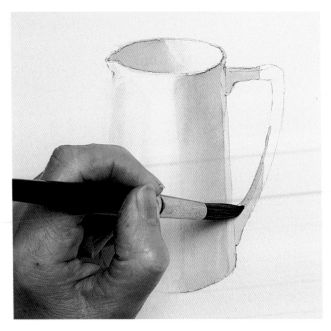

5 Build up the shadows with a glaze of complementary violet over the dry yellow washes, inside the jug first and then down the side. Do not entirely cover the yellow; allow the edges to show. This allows you to see the constituent complementary colours.

6 Use the very tip of the brush for the delicate shape of the handle. Look back at the jug (or photograph) to check you have the shape of the shadow correctly painted. Adjust with tissue or a brush if not.

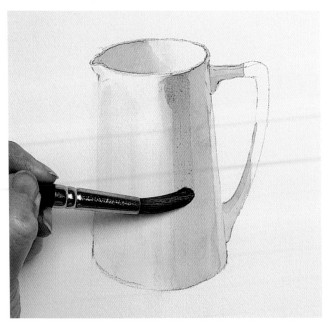

7 Build up the darkest areas of shadow with a further glaze, this time of Phthalocyanine Blue – inside the jug, down the centre at the right side and on the handle. Try to distribute these dark tones around the jug for some tonal balance. If you are uncertain about how dark to go, take it slowly in two or more layers, but allow each one to dry before adding another.

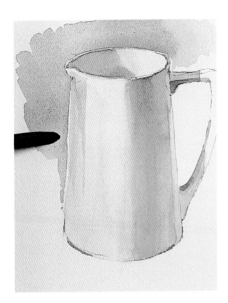 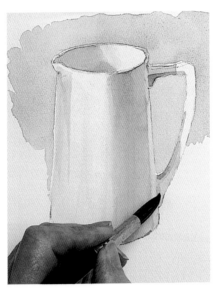 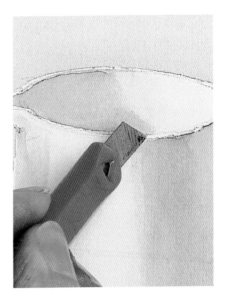

8 The shape of the jug is defined by the background wash of Phthalocyanine Blue; the positive shape (of the jug) comes from the negative shape (of the background). When the jug is dry, add the cool background blue, which links visually with the complementary orange-yellow of the shadows on the jug. You do not want this wash too wet on your brush or it will be difficult to control. Paint it carefully, making sure you paint around the highlights on the rim and down the right-hand side of the body of the jug.

9 Concentrate on the edges again. 'Find' the edge between the handle and the body of the jug by increasing the tone on the handle with more violet.

10 The highlights on the rim have become blurred with paint. They need to be sharp-edged and bright to put across the reflective nature of the hard ceramic glaze. You can do this by scratching out with a scalpel. The brightest highlights will be where the light strikes the jug.

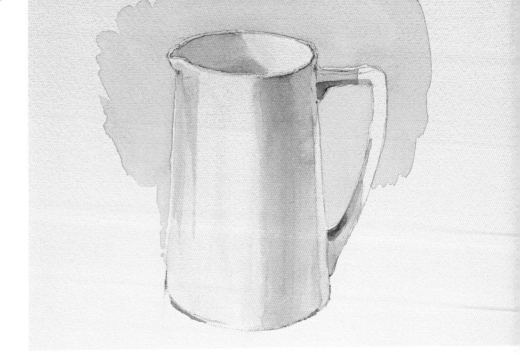

You can feel the warm summer sun on this jug; quite a different jug to the one in the photograph. This one exudes energy and light, which come from the use of complementary colours and the use of pure transparent washes.

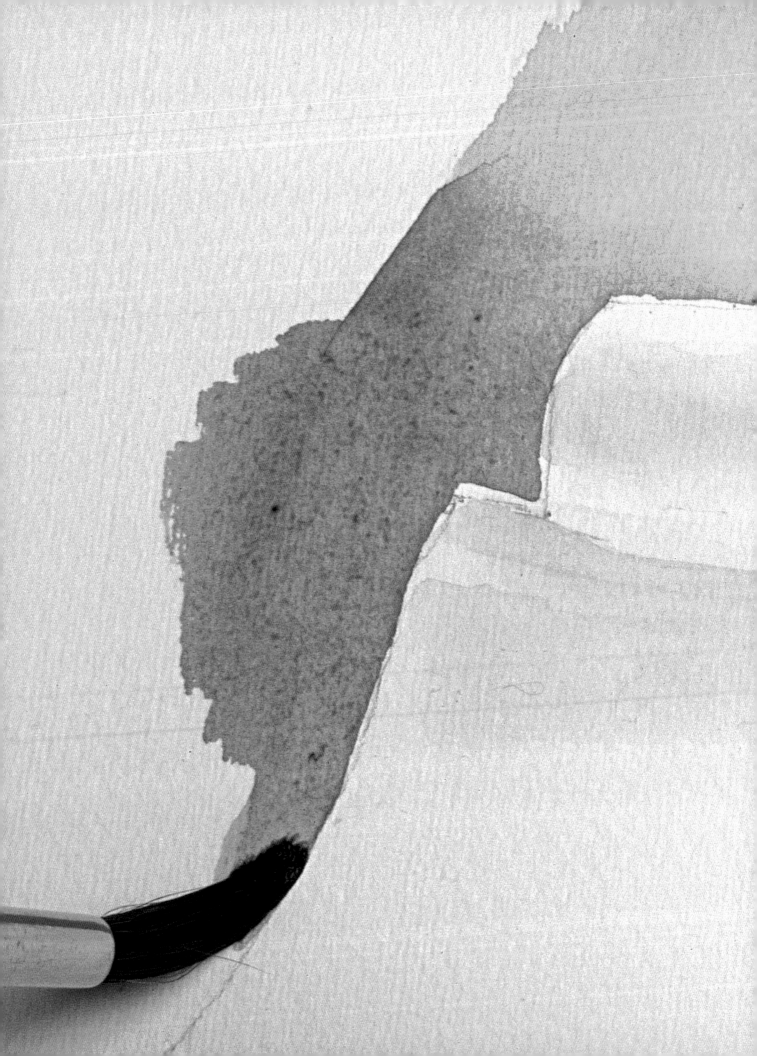

Step 8
editing
information

focus: cloth

Materials

Paper for sketching

Watercolour paper, 300 gsm/140 lb

HB clutch pencil

Round brush, size 12

Clean brush

Small sponge

Tissue/kitchen paper

Watercolours:

• *Quinacridone Gold*

• *Phthalocyanine Blue*

• *Dioxazine Violet*

A simple white cloth, laid out on a table should be just that: simple. Watercolour painting is about giving clues. You do not have to paint every little detail, in this case every crease, every shadow; in fact, as you will see, you do not have to paint the whole cloth. It will be a better picture if you edit out information that is not absolutely essential. First, the artist must decide on a focus for the painted sketch, then how to put across the nature of the cloth – the material, the folds – in as simple a manner as possible. The tonal range, the modelling and the colour of the cloth will be manipulated and simplified. This editing process is something that, in due course, will become second nature.

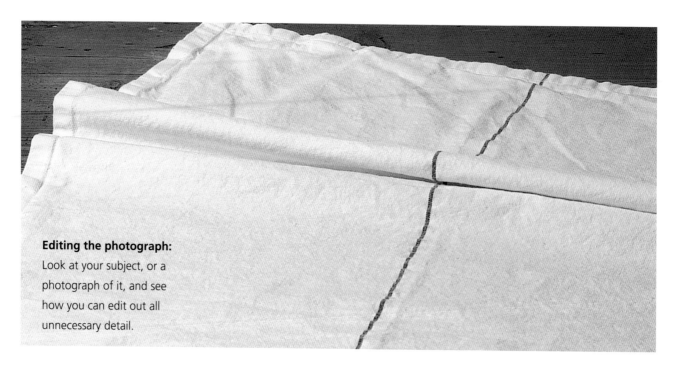

Editing the photograph:
Look at your subject, or a photograph of it, and see how you can edit out all unnecessary detail.

SELECTING AREAS OF FOCUS

You will notice how the artist has started by simplifying and also manipulating the information available – the actual shape of the cloth is slightly changed to make a better picture. The artist has looked at the cloth and decided on the most interesting aspect of it: where the two folds meet at the edge forms an unusual shape so this becomes the focus of this simple painted sketch. As these two folds are the focus of the piece, they are exaggerated and given more of a central role. This gives the cloth some shape and gives you something to work on. The vast area of creased cloth in the foreground is edited out. Other details, such as creases and the sewn hem along the edge, are also ignored.

In the still life in **Step 10 composition**, you will notice that the folds have been further arranged to fit in with the composition. The horizontal folds lead the eye into the painting from the left, as does the blue line in the cloth from the front. Again, the cloth and its folds have been manipulated to make the most of them and any information that is not essential to the composition has been edited out.

Simplifying tonal values

The artist is aware that in the still life the cloth will be playing a secondary role. Working up the contrasts would draw attention away from the true focus of the painting. A weaker light will reduce the extremes of contrasts and make the highlights and shadows paler and soft-edged, allowing the cloth to remain in the background.

Simplifying colour

As with the jug (see **Step 7 energy and light**), the shape of the cloth, particularly the interesting outside edge, is described and given prominence by the addition of the startling background colour. A strong golden yellow is chosen for this, taking its cue from the wooden table on which the cloth is laid but making the yellow more vibrant and removing any detail that indicates that it is a wooden table. The cloth is white so will therefore take on the colour cast of the light. A cool blue is chosen for the shadows, as if reflecting the sky.

Simplifying the modelling

The shape of the folds is described by the edge of the cloth, exaggerated by the background yellow, and also by the blue line in the material, which is therefore given prominence. This means that the shadows on the folds are kept as simple as possible, only giving enough information to make sense of their shape.

PREPARING TO PAINT

The shadow glaze is a mixture of the blue with a touch of violet to neutralize it. These shadows will model the folds in the cloth. To describe the edge of the cloth, use Quinacridone Gold for the strong yellow of the wooden table. For the stripe down the cloth, use a stronger version of the shadow mix.

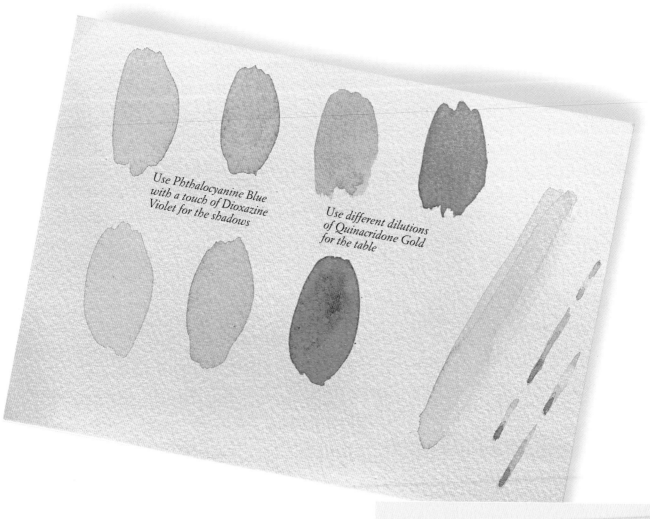

Use Phthalocyanine Blue with a touch of Dioxazine Violet for the shadows

Use different dilutions of Quinacridone Gold for the table

Lifting off with a tissue: The blue line in the cloth will look more natural if it is not painted as a solid stroke. As it is transparent violet, it will be qualified by the shadow colours underneath, which will vary the tone. You can further break it up by lifting off paint with a screwed up tissue. Take care to turn the tissue before you dab again or you will end up adding paint where it is not wanted.

PAINTING THE CLOTH

For this project, the drawing is important and the pencil lines play a part in the final painting. This does not mean that they have to be any darker than usual, but you will be aware of them, if only subconsciously, in the final painting.

1 First, wash in the cool, neutral, glazed shadows. While still wet, soften the edges by running along them with a clean, slightly damp brush.

2 The next band of shadow, on the flat cloth beyond, acts as a negative shape, defining the crisp positive highlighted edge of the main fold.

3 The shadow on the foreground fold is slightly darker because it is closer, and with a hard top edge and softened bottom edge.

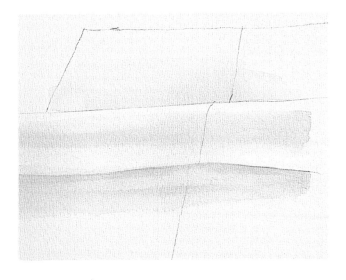

4 The hard edge along the top of the front fold is softened in places with a clean, damp sponge to vary the focus.

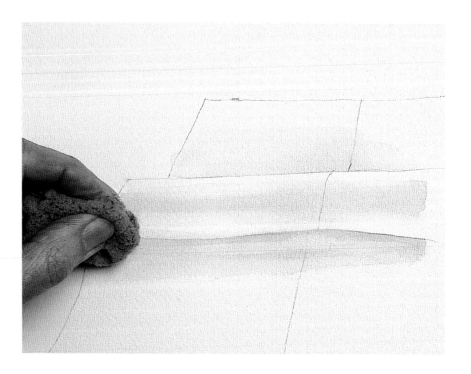

5 Once quite dry, add the high-strength background yellow, paler in the background and stronger in the foreground, bringing out the edge of the cloth. Tip the board the other way so that the high-strength colour travels and merges with the more dilute colour at the top. If you allow more dilute wash to drip down into the higher strength one, 'cauliflowers' will form – hard-edged, foliage-shaped patterns that will disturb the even wash.

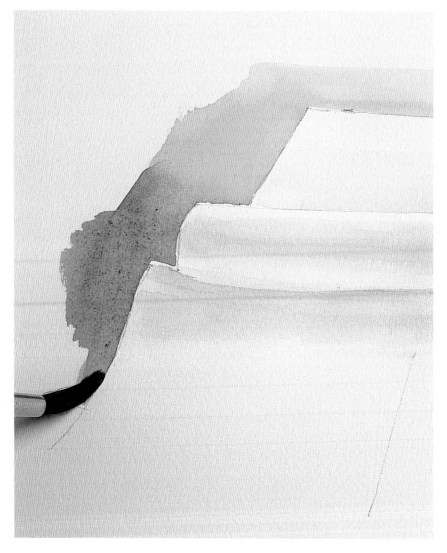

6 Add the blue line on the cloth. Start at the back, with the colour more dilute to suggest distance into the picture space. As you come forward, make it darker and slightly wider.

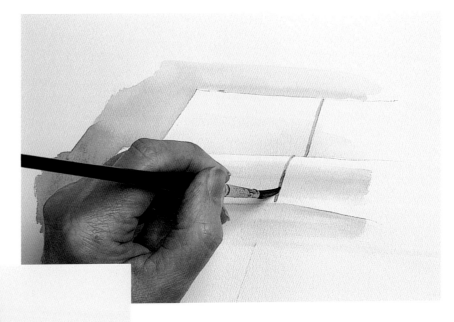

7 You do not want the line to look too consistent so blot with a tissue at intervals. As it is a transparent glaze, it will vary in tone according to the shadow washes beneath but you may need to intensify the colour over the shadow parts to make this clearer.

With the very basic information provided, the eye can read this painted sketch as a piece of cloth with folds. By simplifying the information, there is no confusion and it is clear what the artist is painting.

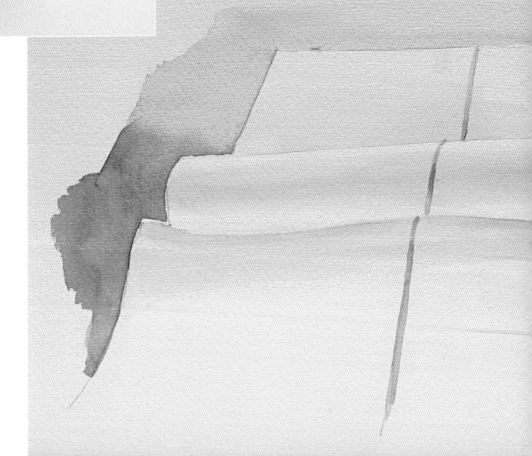

Step 9
creating drama

focus: background

Materials
Paper for sketching
Watercolour paper, 300 gsm/140 lb
HB clutch pencil
Round brush, size 12
Clean brush
Sponge
Tissue/kitchen paper
Watercolours:
• *Quinacridone Gold*
• *Phthalocyanine Red*
• *Phthalocyanine Blue*
• *Dioxazine Violet*

Adding a background colour can greatly enhance your painting. It can help to describe the object as a negative shape as with the jug (see **Step 7 energy and light**) and cloth (see **Step 8 editing information**), or thrust an object forward emphasizing the three-dimensional as with the orange (see **Step 4 watercolour layers**). For the pear (see **Step 5 texture**), the yellow background represents the surface on which it stands and on which its shadow falls, setting the pear in its three-dimensional space. A background can also set the painting's mood, through cool and warm colours and through dramatic techniques.

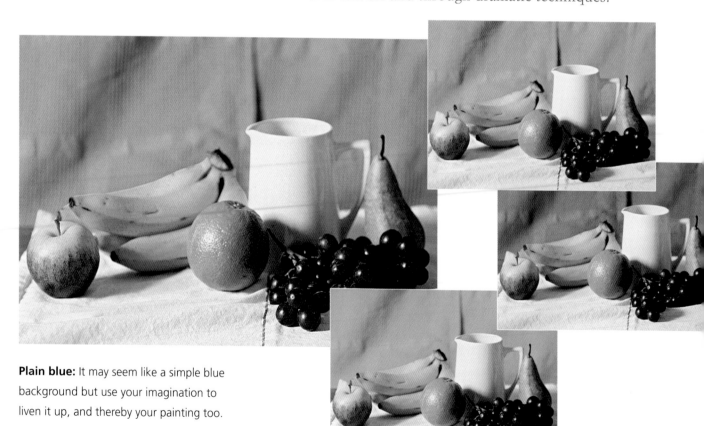

Plain blue: It may seem like a simple blue background but use your imagination to liven it up, and thereby your painting too.

MOOD

Colour and texture in the background can set the scene for your painting, whether it is for a surreal dreamscape or a down-to-earth flower arrangement. With colour, suggestions of summer warmth will come from sunny yellows and similar warm colours and the resulting sensation will be light-hearted. Cool blues and deep violets will inspire icy temperatures and dark thoughts. Moving into the realms of psychology, you can use your imagination to put across an idea – misty washes for calm; strident flashes for chaos. The options are infinite.

Movement

Background colours do not have to be flat and static; they can be built up in layers, using complementary colours to produce dark browns and coloured greys, allowing the colours to mingle unevenly to produce some movement. If you superimpose violet over yellow, touches of the pure constituent colours can be left to catch the eye and give the background area some movement and life. Movement can also come from explosive mixes of paint as in the demonstration, pages 97–99.

Focus

The background can play a part in creating a focus in your painting, particularly by building up contrasts around the focal point. In the still life (see **Step 10 composition**), the focus has been chosen as the jug. The background here is deepest in tone, contrasting with the bright highlights of the white jug, and drawing the eye to these depths of tonal value.

Drama

A sense of the dramatic, incorporating movement and energy, can be put across both with colour and with explosive techniques. This was the aim with the demonstration below. You can see how the outcome is difficult to predict and for the still-life painting (see **Step 10 composition**) the more fail-safe method of superimposing layers wet on dry was chosen because it is easier to control and predict the outcome. There are many other techniques to choose from for an exciting background. Use your imagination and see what happens.

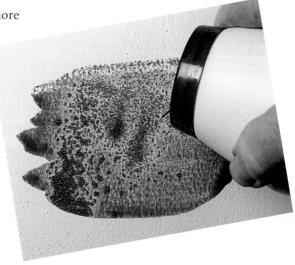

Salt: For a mottled effect that is less fabricated than a stippled surface you can use salt. Once you have laid down a wash, sprinkle salt over the area. The salt will only affect the wet area, so as long as the rest of your painting is properly dry you can restrict this salting to the background area. Rock salt and ordinary table salt will produce different effects. Allow to dry before wiping off the salt crystals.

Wax resist: Gently rub the stub of an ordinary white candle over the surface of the paper. The roughness of the paper breaks up the candle 'stroke'. Once you paint over the top, you can see where you put the candle because the waxed area repels the paint. This effect is most dramatic when the wax conserves the white paper but it can also be interesting to conserve an initial dried wash.

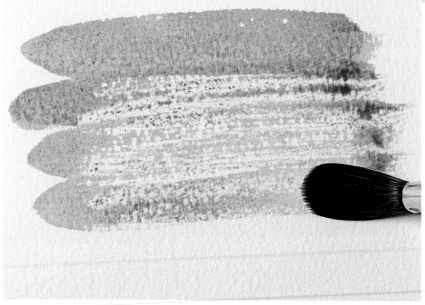

PREPARING TO PAINT

The first warm yellow wash is Quinacridone Gold with a touch of Phthalocyanine Red to further warm it up. The purplish-blue is Phthalocyanine Blue and Dioxazine Violet; a more dilute mix for the first application, followed by a stronger mix. Make sure the gold spatter mix is not too dilute or it will disappear into the blue wash.

PAINTING THE BACKGROUND

Your aim is to produce a dramatic background and, indeed, the process is a small drama in itself. Be brave! Have everything ready before you start, as you will need to move fast. Make sure you have plenty of ready-mixed paint as you will not have time to stop and remix. The plan is to wet the area with a sponge and brush, wash in the first yellow colour on the left, then quickly mop in dark purplish blue on the right to merge with yellow at the edges. Add a stronger mix of the same wet in wet. Finally spatter in a strong mix of Quinacridone Gold.

1 To give you something to paint around, draw a rough outline of the still life we will be painting in **Step 10 composition** (see page 106). Wet the broad area of the background with a sponge, using a brush with water for the more intricate parts around the still life (see detail).

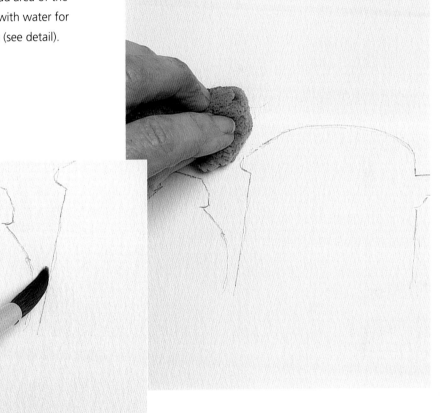

2 Allow the water to sink in but do not let it dry out. Touch in the warm yellow on the left, allowing it to spread.

3 Quickly mop in the dark purplish blue, encouraging it to blend with the yellow. Tip the board to take the colour where you want it to go.

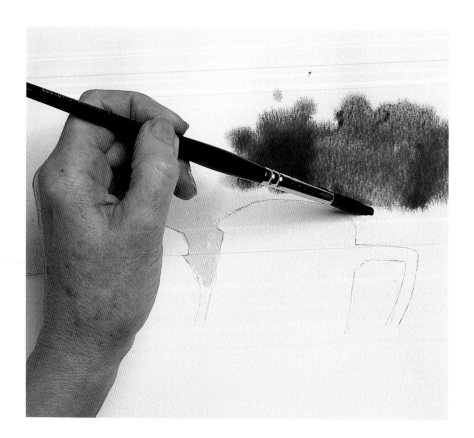

4 The blue is not spreading enough into the yellow so the artist takes more blue over to the yellow with the very tip of the brush and a spidery stroke.

5 If the paint dribbles or collects along the edge, take it away with a squeezed out brush.

6 Keep going! To increase the depth of tone around the top of the jug, add a still stronger purplish-blue mix wet in wet. Try not to disturb the wash below; drop the paint off the tip of the brush. Tip the board again to control the spread of colour.

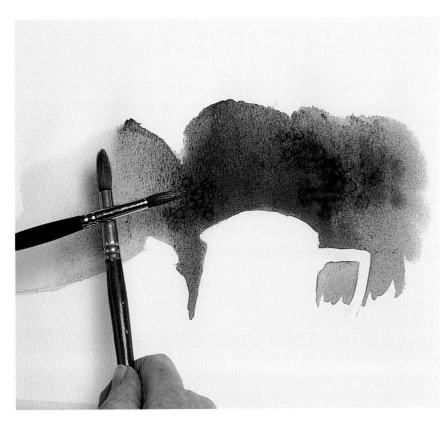

7 One final addition: a spatter of Quinacridone Gold at intervals across the background area is another way of building up texture and tone at the same time. Your gold mix should not be too dilute. Load your brush and then tap it down on another (clean, dry) brush – gently, or you will cover a wide area with droplets of paint. Continue to tip the board to control the blending of the colours until the paint has settled. Do not be tempted to touch it with a brush. Let it dry and see what happens.

The result, when dry, is certainly dramatic. There is a sense of movement and light behind the jug.

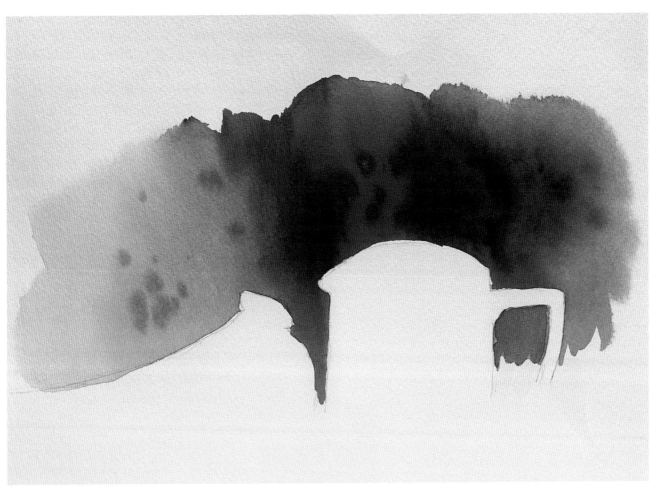

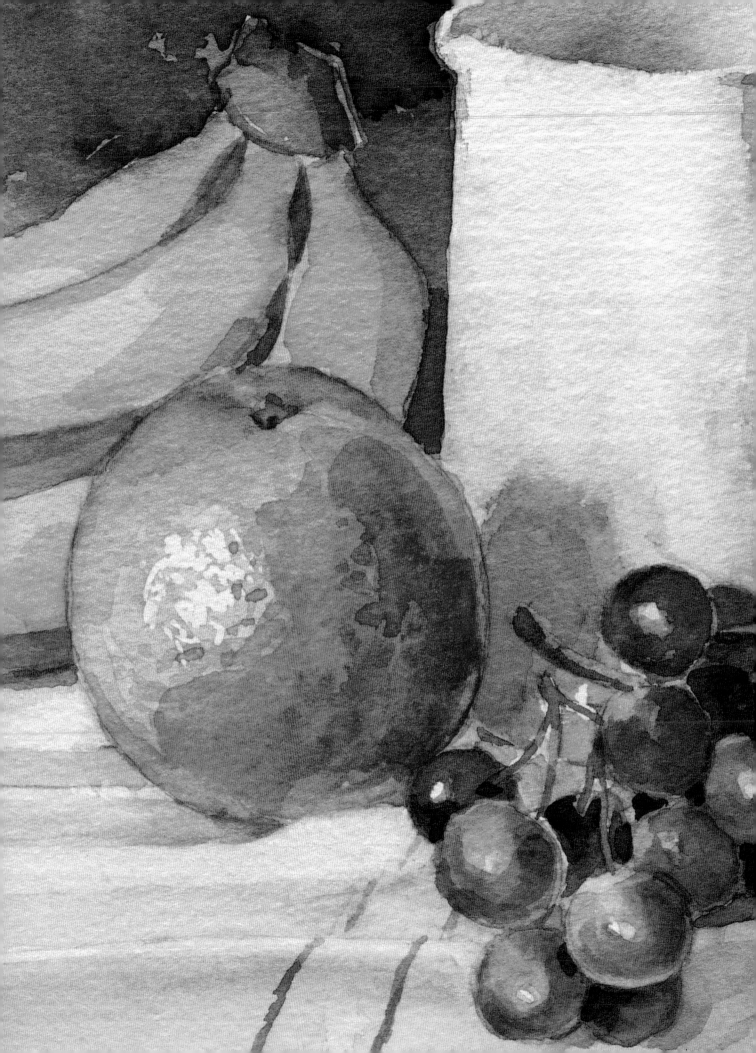

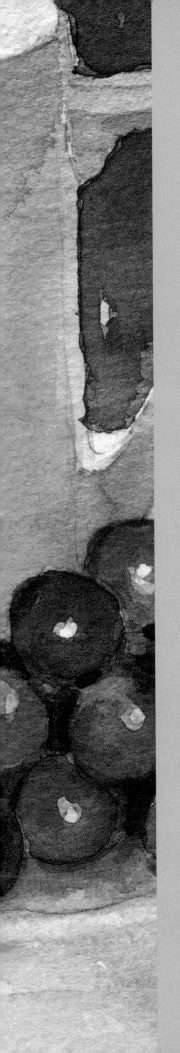

Step 10

composition

focus: still life

Materials

Paper for sketching

Watercolour paper, 300 gsm/140 lb

Masking fluid

HB clutch pencil

Round brush, size 12

Old brush to apply masking fluid

Tissue/kitchen paper

Atomizer

Watercolours:

• *Phthalocyanine Red*

• *Alizarin Crimson*

• *Quinacridone Gold*

• *Lemon Yellow*

• *Ultramarine Blue*

• *Phthalocyanine Blue*

• *Dioxazine Violet*

You are now ready to paint the still life. First, however, you must consider the options for the composition, bringing together the various parts of the still life and considering some ideas on how to decide on the final arrangement. You will want the result to be pleasing and yet challenging. Your composition will need rhythm and movement even though it is a still life. In the course of trying various options, you will consider how the elements – the fruit, jug and cloth – link with each other. You will see how you can control the way the viewer looks at your composition by leading the eye along pathways of light and colour. You will be considering the light; the direction it is coming from as well as the strength. Finally, you will look at cropping the arrangement to enhance the elements in the picture and to concentrate the natural energy of the composition.

Natural harmony: You can move the elements of your still life around until they feel right – then you can work out why there is a natural harmony.

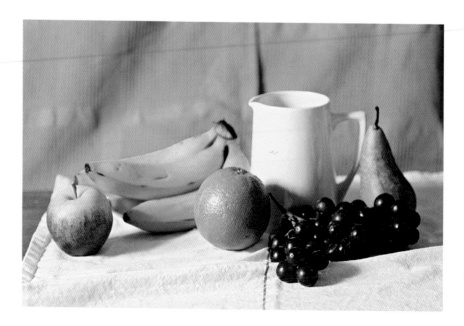

ARRANGING THE ELEMENTS

There are so many ways you could arrange these five pieces of fruit, the jug and cloth. What you are looking for is an arrangement where each element is seen to its best effect and yet is linked with the other parts, so that they all work together in a perfect whole.

Directional lines

The individual pieces can be linked by directional lines, that is lines that are already there in the composition – such as along the edge of the cloth, or the curve of the banana. Such lines can also be created by folds in the cloth or shadows, and indeed can be introduced in the painting process by directional brushwork. It is a good idea to link these directional lines in a circle so that the eye travels around the painting, lingering for a while.

Example 1: With this first arrangement, the eye travels in from the left, nicely picking up the edge of the cloth. It then smacks into the horizontal upright of the jug. Once beyond this, the fruit either has lost its identity, like the bananas and grapes, or is arranged stiffly in a row. The eye hops unhappily from one item to another. It then finds the stark edge of the cloth on the right and gratefully makes its escape.

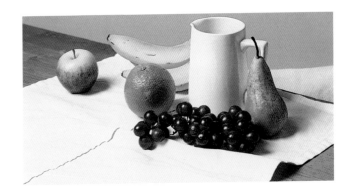

Example 2: As before, the eye picks up the edge of the cloth, travels into the orange and down the top edge of the banana to the grapes. Now it picks up the stalk of the grapes leading on to the pear, up to the apple, along the edge of the cloth again to the jug. Without realizing it, the eye has passed through all the various elements. The arrangement however, is not quite right. It does not hold together and the wonderful shape of the pear is lost.

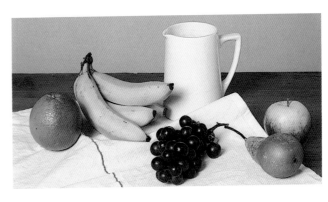

Example 3: Here, the structure behind the idea is more geometrical, looking at the lines made by the edge of the table, the cloth and the diagonal made by the arrangement of fruit with the jug standing at the end with its back to us. It would be worth exploring this idea.

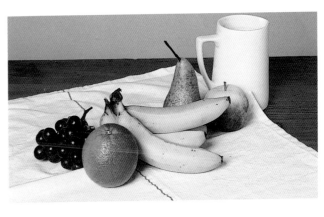

Example 4: This arrangement looks more natural. The fruit sits in interesting positions and is visually linked even though each element retains its individuality. The arrangement has a symmetry and balance and yet the dominating jug is not in the middle. The eye is taken in from the left as well as from the front along the blue line in the cloth.

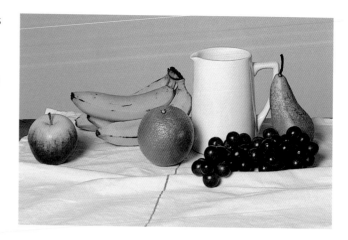

Viewpoint

You can make a dramatic change in your still life by altering your viewpoint. It need not be too extreme to make a difference.

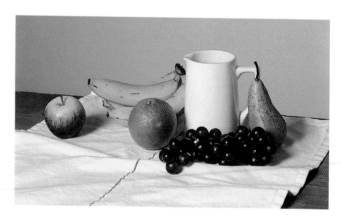

Example 1: Seen from above, the height of the jug is lost, as is the interesting shape of the bananas. The arrangement loses its energy and appears to fall apart.

Example 2: Try looking at an arrangement obliquely from the side. This can often open up some unexpected shapes and conjunctions. Moving slightly to the right side isolates the apple in an interesting way and the angles on the cloth edge and blue line are good.

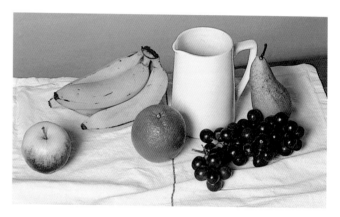

Example 3: An oblique view from another angle completely changes the arrangement. The outline of the pear lounging against the jug is particularly interesting. This is a viable option.

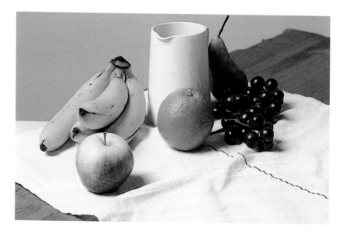

Manipulating the light

Changing the angle and the strength of the light will also change your composition. The angle of the light will affect the shadows which are useful in linking the various elements. Altering the strength affects the balance and mood of your painting.

Example: The light is bright here and raking in at an angle from the left. It casts good shadows that help to link the fruit. It also has the effect of increasing the depth of the painting. Compare it with Example 4 at the top of page 104, where the light is coming from behind the viewer. The arrangement looks flatter and without shadows the elements are more isolated. Bright light has the effect of exaggerating light and dark, cutting out the range of mid-tones.

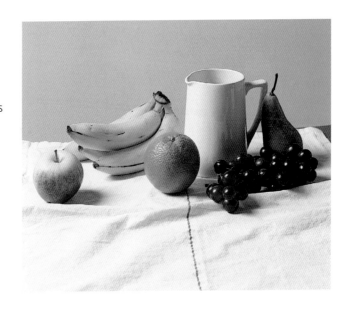

Cropping

Cropping into your frame to focus on a certain part of your composition can dramatize the subject in an interesting way, concentrating the energy in a smaller space. Make a small frame with some white paper and try cropping some of the other arrangements to see how this can transform a rejected composition.

Example: You will find that by cutting an element of the composition with the frame, as here with the apple and grapes, it pins them in the foreground and pushes the rest of the composition back.

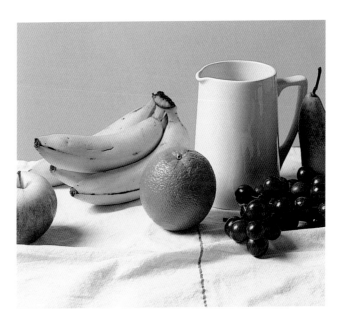

PREPARATORY WORK

Having decided on the composition of the still life, there is some further preparatory work to be done. First, sketch the composition to produce a simple outline to be used as the under-drawing. Next, you will need to make a sketch to look at the distribution of tone so that it can be manipulated to make the best of the composition.

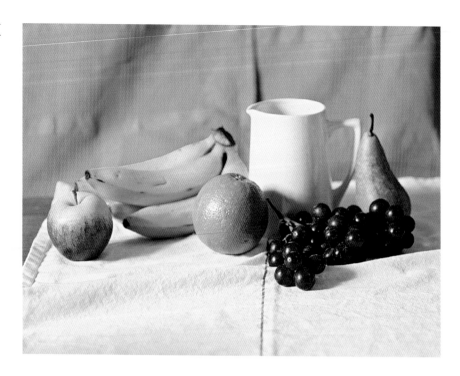

Under-drawing

While preparing the under-drawing the artist makes final decisions about cropping and, even at this stage, makes some adjustments to the arrangement chosen for the still life. These small changes are made to help the picture work, encouraging the viewer to look at the painting from all angles.

The elements of the still life are slightly adjusted: the bananas are separated from the jug, creating a visual break at this point so that the eye travels down to the orange and around the other elements in a circle back to the jug. There are extra grapes to make more of this element and the pear is given more body so that it gains visual weight. Also important for the composition is the manipulation of the cloth: the folds are exaggerated, a second blue line has been added for extra emphasis and the lines, which provide another pathway into the composition, are taken in at a more interesting angle. The corner of the cloth visible behind the apple is edited out because it interferes with the purity of the apple's outline and is distracting.

Once you are happy with the drawing, transfer it to the paper you will use for the painting (see page 39).

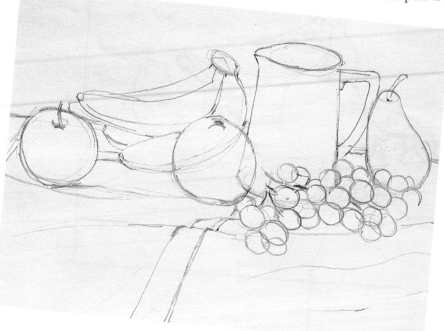

Tonal sketch

For this sketch, you are looking at how the light and shade models the different parts of the still life. First, shade in the mid-tones, leaving the lit areas as the white of the paper. Add the darkest areas of shadow last. The harsh light shining down at an angle from the left casts interesting shadows. This means that the highlights will uniformly be on the left and the shadows will fall on the right. The pear is in the shadow of the jug but will still have a lighter and darker side according to the light source.

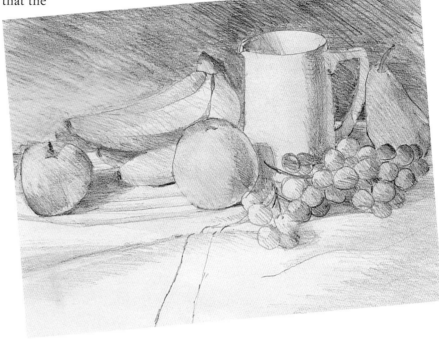

Subtle adjustments

Having established the reality of the light and shade as it appears in the photograph, you can now alter it subtly to make sense of your painting. Note how the artist has increased the tone above the jug so that this becomes the area of highest contrast – the dark background balancing the white highlights on the jug. This acts as a focus, drawing the eye into the composition. The shadows between the elements of the composition are edited to emphasize them as links between the apple and the bananas, and the orange and the jug.

Little points of extreme dark tone are added. If you look at the photograph of the still life at the top of page 106, you will see that these exist: the stalks of the apple and grapes; the ends of the bananas; where the apple, bananas and orange meet with their shadows on the cloth; and the interstices of the bananas. The artist has then gone on to add the tiny triangular gap between the pear and the handle of the jug and the tops of the grapes against the pear. This galvanizes this area, which otherwise becomes too neutral in tone.

PREPARING TO PAINT

Before we start painting, it is worth looking at the slightly different approach necessary for this larger painting with its varied collection of fruit. If you paint each piece of fruit individually, the painting will not have harmony: it will not hang together. It has to be approached as a whole, starting as you did with the smaller studies, with general overall washes and working up to more detailed treatment but this time over the whole composition of fruit.

PAINTING THE STILL LIFE

You are now ready to paint. Every part of the painting has been carefully studied and practised. The first brushstroke can be daunting, but you will be starting with general washes to set the tone. As you have practised this in a number of the study paintings, it will not be a problem. We will work in five stages: the first three stages concentrate on building up colour, tone and structure, the fourth stage deals with giving the painting its three-dimensional effect, and the final stage is for fine tuning.

Stage 1

1 The work area is set up. The paper with the under-drawing is fixed to the board with masking tape as shown on page 25. In front of the artist is the actual still life. The tonal sketch and other references such as colour photographs of the still life and various details photographed when working through ideas for the composition are placed at the top of the board. Strong versions of the selected colours are laid out in plastic pots. The colours will be mixed on a sheet of watercolour paper laid out on the table next to the pots of colour.

2 After setting up, the first step is to mask off fiddly areas of highlight that will be difficult to paint around when the first washes go on. Paint masking fluid onto the handle and rim of the jug and the highlight at the base of the pear stalk, then mask a few stippled highlights on the orange with the tip of the brush, as well as the point of highlight on each grape and the stalks. Allow the masking fluid to dry before you add any paint.

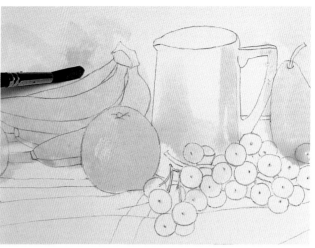

3 The general washes are now applied. These next steps need to take place quickly so have paints and water near to hand. Use an atomizer to spray the paper with clean water. This wets the paper quickly and evenly.

4 Wash cool Lemon Yellow over the yellow fruit, and the reflected colour on the jug. It will spread beyond the fruit into the background. That is fine.

5 Before the yellow wash dries, add warmer Quinacridone Gold in the background above the jug, into the mouth of the jug and down the shadow side, the base of the pear and the grapes. As the paint goes on, it looks rather alarming. Do not worry. It will even out and dry paler.

6 Any stray dribbles of paint can be lifted off with a tissue. Here the small but important points of light, seen through the handle of the jug, are wiped clean of paint. You can see the Quinacridone Gold has been taken down to the white cloth to suggest the warmth of the light.

7 While the surface is still wet (respray with water if necessary, keeping the atomizer far enough away from the paper to apply just a light spray), seek out areas of warm reds with Phthalocyanine Red. Now allow your initial washes to dry. You can speed this up with a hairdryer but wait until the colour has settled and been absorbed into the paper or the jet of air will move the paint.

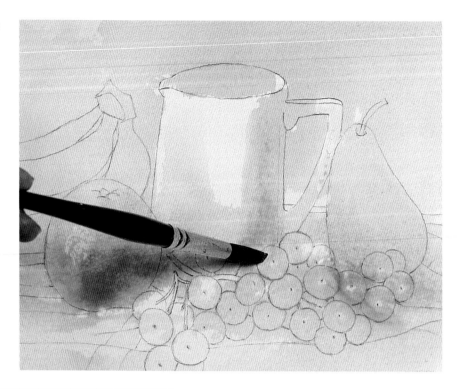

8 This is a moment of calm after the action of the washes. Assess your progress before moving on to Stage 2. As promised, the washes dry paler and more evenly blended. Check that areas of highlight have been conserved as white. Lift off with a wetted brush if not.

Stage 2

9 Soften any hard edges or 'cauliflowers' (see page 90) that have developed with a wetted sponge – stroke gently.

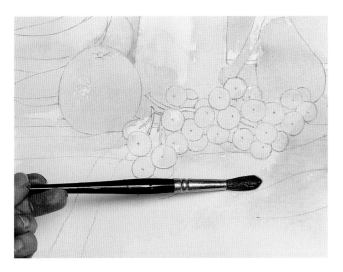

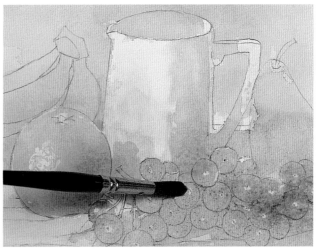

10 Continue with the washes. Spray the surface again with water and this time add cool Phthalocyanine Blue along the top of the background so that it drops downwards and over the far left- and right-hand sides, over the pear and cloth. It is interesting to see how the colours combine to make a range of neutral greens and blue-greys.

11 We are about to move fast again, building up the colour wet in wet. First, the Dioxazine Violet is washed over the grapes, and the shadows. A mixture of Quinacridone Gold and Lemon Yellow goes over the orange and bananas with Phthalocyanine Red added to the orange to bring out the warmth and to keep it in the foreground. Take this wash over to the shadow on the jug, linking them with colour. Do not forget to leave the strip of light down the edge of the jug. The colour looks extreme but it will mellow when it dries.

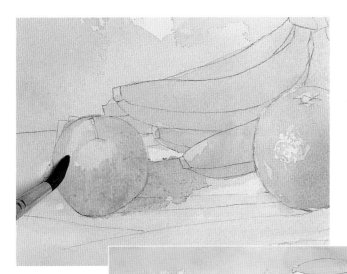

12 Give the apple a touch of yellow on the top and then paint some Alizarin Crimson on in descriptive strokes as practised in the study. The crimson bleeds into the violet of the shadow. You can see how the bananas have been painted warm yellow in the front and left cool green-yellow at the back. Allow to dry.

13 Stop and assess your work for balance and tidy up any splashes or hard edges. In the next stage, we remove the masking fluid and deal with edges.

Stage 3

14 Remove the masking fluid with a putty eraser (or clean finger). Just rub lightly and it will come away.

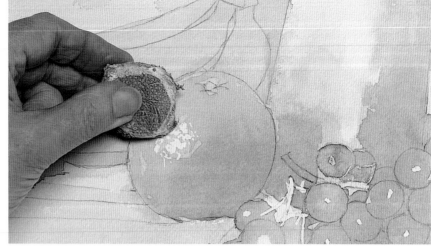

15 The paint has dried strong and hard along the bottom edge of the shadow of the apple. First, lightly work with a clean, damp, hog-hair brush to loosen the paint and soften the edge, then blot with a tissue to remove the loosened paint.

16 Now we model with colour. Stronger colour is added wet on dry, defining the shape of the fruit with the brushstroke. First, work on the grapes with a mix of Alizarin Crimson and Dioxazine Violet. Use the brush to express the curve of the grape so that you do not disturb the underlying washes. Paint around the highlights – do not worry if the brush strays as they do not need to be bright white and some will be brighter than others. The blended colours of the washes beneath this layer of purple help to keep the colour uneven, which is closer to reality.

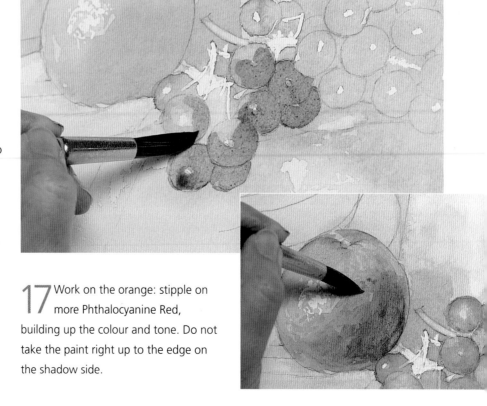

17 Work on the orange: stipple on more Phthalocyanine Red, building up the colour and tone. Do not take the paint right up to the edge on the shadow side.

18 Build up the tone of the shadow of the orange on the jug with complementary Dioxazine Violet. Take the violet glaze, wet on dry, down the right-hand shadow side of the jug, over the shadows on the handle (see detail).

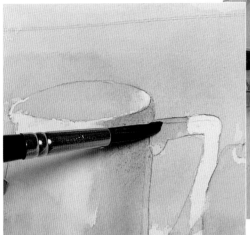

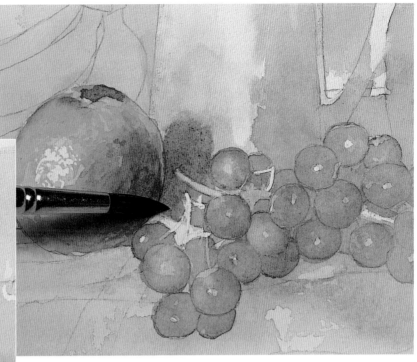

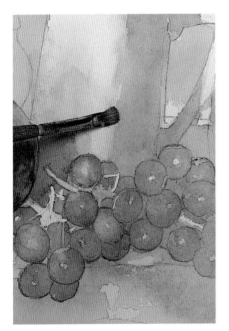

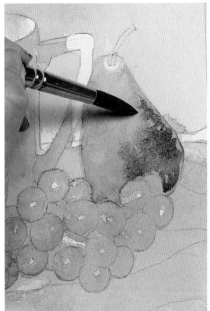

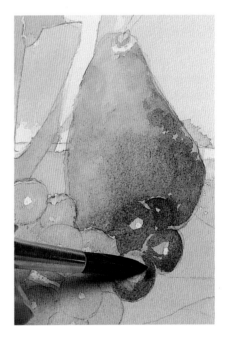

19 If the shadow edge down the middle of the jug has dried too hard, use a hog-hair brush to soften it with a little water.

20 Apply a general under-wash of Quinacridone Gold and Dioxazine Violet and a touch of Phthalocyanine Blue to the pear. Let it dry off a little and then stipple a stronger mix of the same for the shadow.

21 Add more colour to the grapes, then take a little of the colour across to dab onto the pear or allow the colours to run together. This will give texture to the skin of the pear and link these two parts of the painting.

22 Turn to the shadows on the cloth. Start at the top with a glazing mix of Dioxazine Violet and Phthalocyanine Blue. Take the shadows horizontally across, to balance the verticals in the still life. For the lower part, clean your brush and squeeze it gently in a tissue. Add a little dilute glaze colour and scrub it over the shadow parts, holding the brush sideways. This will produce a layer of broken colour.

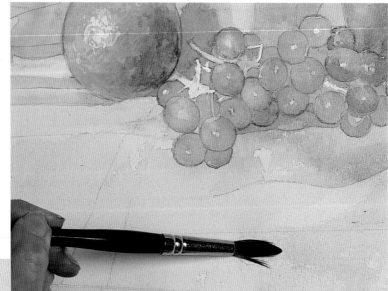

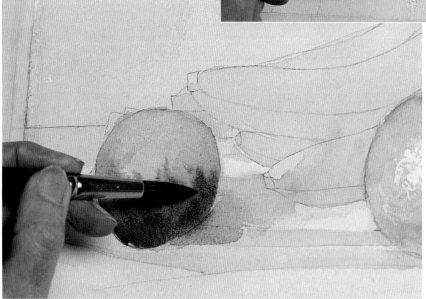

23 Now work on the left side of the painting to bring it to the same level. First, wet the apple with water and allow it to sink in. Then add directional strokes of a mix of Quinacridone Red and Alizarin Crimson to strengthen the colour and describe the shape of the apple. The red does not run into the paler under-washes at the top because the board is on a slope. Add a dab of the red in the stalk well.

24 Glaze the bananas with Dioxazine Violet, as practised on page 74, picking out the shadows. Then paint the tips in brown, a mixture of Dioxazine Violet and Quinacridone Gold. Now let it dry once more so you can assess your progress.

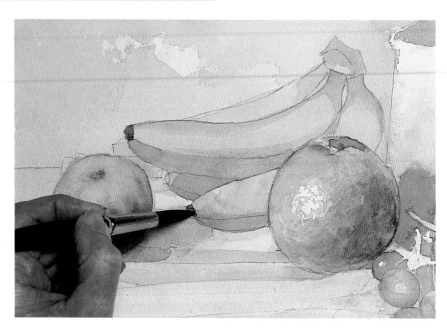

25 Study your painting. It should now be looking good but it may lack punch. The structure – the three-dimensions – of the still life needs more attention. Do not worry. Once the background goes in, it will show up the outline of the still life and increase the three-dimensional effect. Finer details such as stalks will also strengthen the painting.

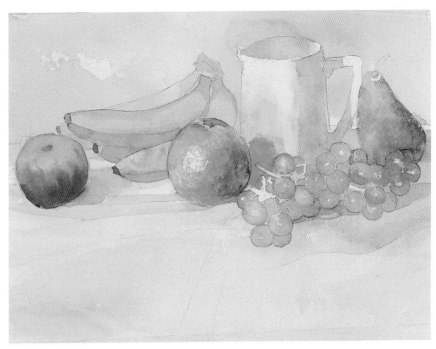

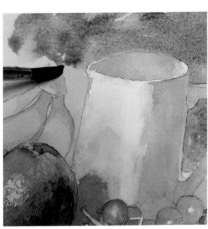

Stage 4

26 Now comes the rather dramatic step of adding the background. Start gently, wet on dry, with a mix of Phthalocyanine Blue and a little Dioxazine Violet. Use this as a first wash and feed in stronger colour wet in wet.

27 Add the violet and the blue alternately, but keep the colour warmer on the left, cooler on the right. If you stray, let it dry and remove with a hog-hair brush and a little water, or scrape with a blade as shown on page 79.

28 The area around the jug will need to be darker to contrast with the paleness of the jug, making this a focal point. Add stronger colour here, wet in wet.

29 Now we build up the structure, concentrating first on the grapes. The grapes behind will be cooler and bluer, the ones in the foreground, warmer and redder. Add another darker curved stroke on the grapes for a more three-dimensional effect.

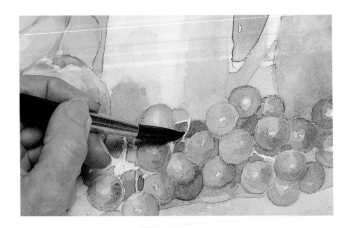

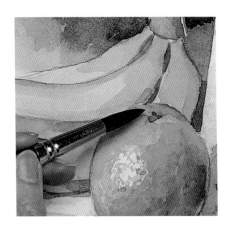

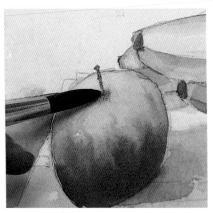

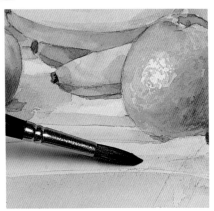

30 The bananas get the same treatment as the grapes, building up the shadows with further glazes of violet and blue as in the study (see page 72–4), and adding more yellow to strengthen the colour. They are in the background though, so not too detailed. Use the dark brown for the negative space between the tops of the bananas and for the touch of dark shadow at the base of the orange.

31 Add the final details to enhance the structure. With the tip of the brush, paint the apple stalk and the grape stalks with a mix of Dioxazine Violet, Quinacridone Gold and Phthalocyanine Blue.

32 Add more shadows on the cloth – use a mix of Phthalocyanine Blue and Dioxazine Violet.

Stage 5

33 Assess your progress. If you have lost your objectivity, try looking at your painting in a mirror. This is a particularly useful technique in the final stages.

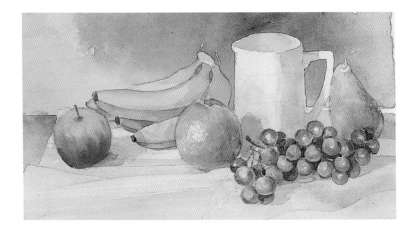

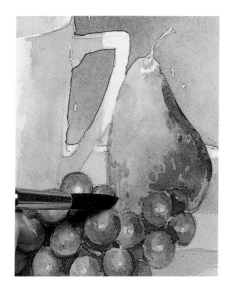
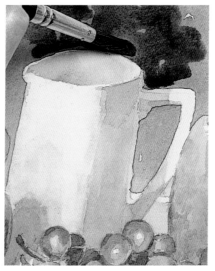
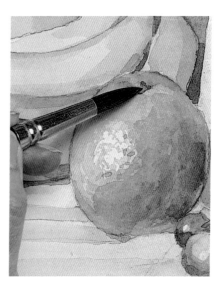

34 All the fruit will be given another layer to strengthen colour and tone. The pear needs another layer of stippled Dioxazine Violet and Quinacridone Gold to build up the three-dimensional effect. The stalk is added with the same mix but stronger, leaving a fine line of highlight along the edge. A touch of red will catch the eye. Notice the high contrasts on this detail.

35 Now the fine tuning: the shadows on the jug are strengthened and then the background area behind the jug is given another layer of Dioxazine Violet, Phthalocyanine Blue and Quinacridone Gold. Don't forget to pick out the tiny triangle between the pear and the jug handle as well as the left side of the jug and the bananas, which were isolated in the tonal sketch.

36 Add final touches of dark brown across the painting to match up with the pear stalk: at the base of the apple stalk, the ends of the bananas, the interstices of the grapes and finally the calyx of the orange. It is a good moment to check your tonal sketch to see what objective decisions you made at the beginning. Finally, add the blue lines on the cloth as practised on page 91.

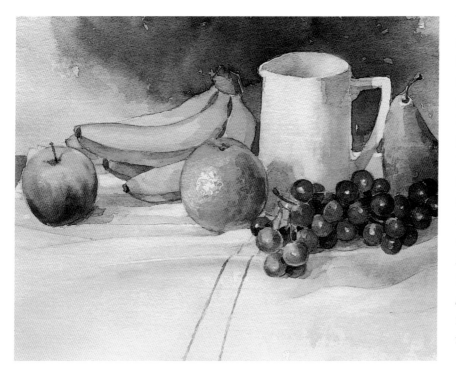

The effort put into the painting has paid off. It is finished and, once dry, the masking tape can be carefully removed. This has a startling effect and you can see that the gradual build-up of glazes on the cloth has produced a subtle area of colour, with the blue lines leading the eye deep into the picture space to the area of high colour in the still life beyond. Here the layers of pure colour pulsate with energy, drawing in the eye, and the moody blues in the background add drama and movement beyond, throwing the fruit and jug forward in a powerful three-dimensional effect.

taking it a
step further

painting landscapes

Materials

Paper for sketching

HB clutch pencil

Watercolour paper, 300 gsm/140 lb

Masking fluid

Round brush, size 12

Flat brush, size 12

Small hog-hair brush

Rigger brush

Clean damp brush

Old brush to apply masking fluid

Watercolours:

• *Burnt Sienna*

• *Alizarin Crimson*

• *Dioxazine Violet*

• *Prussian Green*

• *Raw Sienna*

• *Green Gold*

• *Cobalt Blue*

• *Phthalocyanine Blue*

• *Indigo*

With the skills you have gained following the ten steps on the previous pages, you will now be ready to tackle a seascape. Although the elements are different to a still life, the preparation is broadly the same: simplifying the information, choosing a viewpoint, balancing tonal contrasts and warm and cool colours, and checking the underlying geometry of the composition. The palette is chosen with the colours of the landscape in mind. This tale has a twist, however. In the last stages of painting, the artist was dissatisfied with the waves in the bay and resorted to some artistic first aid. You will see that with watercolour painting, you can hardly ever say 'all is lost.'

Composite: Often you will have a number of photographs of a holiday destination but none of them quite represents your memory of the place. You can build up a composition using elements from a range of views – the shoreline from one, a patch of jungle from another, a shade of blue in the sea from one more.

EDITING THE SCENE

For a landscape, you might think that the information is fixed but this is where you can use artistic licence. A landscape view can be 'arranged' in the same way as a still life; you can edit out unsightly or compositionally awkward elements, although a pleasant view is not always the aim. The arrangement must make sense. Usually, having chosen a landscape view, you will want to reproduce it as closely as you can in your painting – only tweaking it to optimize the composition. For this project, there are a number of photographs of a holiday beach scene and the artist picks elements of each of them to build the composition.

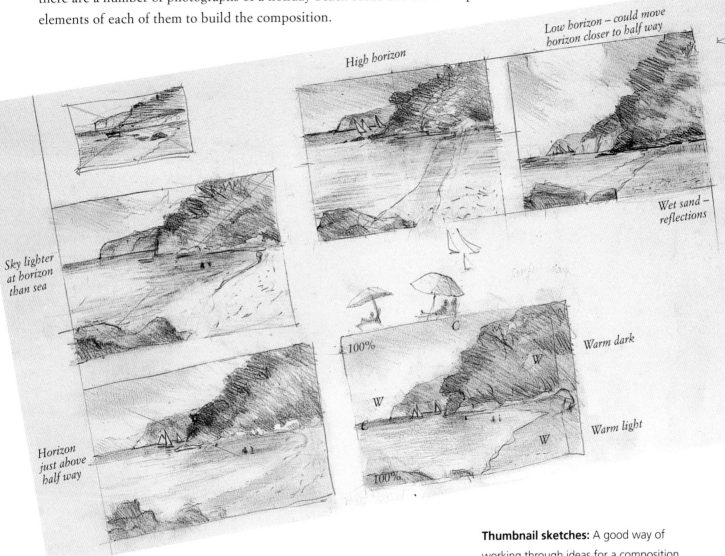

High horizon

Low horizon – could move horizon closer to half way

Wet sand – reflections

Sky lighter at horizon than sea

Horizon just above half way

Warm dark

Warm light

Viewpoint

The artist explores a change of viewpoint in thumbnail sketches. The viewpoint of the artist when looking at a landscape will greatly affect not only the physical result but also the emotional response. As you can see in the sketches above, a high viewpoint will cause the bay and beach line to dominate the composition and the sky to be proportionally reduced. From a low viewpoint, the sky opens out and dwarfs the landscape.

Thumbnail sketches: A good way of working through ideas for a composition is with thumbnail sketches – small, quick drawings in which you can explore options. Here, ideas for figures on the beach or in the water are considered and rejected. Tonal aspects are considered too, plotting the extremes of contrast.

Balancing the geometry

A seascape has a strong horizontal element, set by the horizon and the ranks of waves. Here, the shoreline on the right introduces a welcome series of diagonals. However, the weight of these could bring too much emphasis to the right-hand side of the painting, so the artist devises an opposing diagonal in the clouds to give some balance.

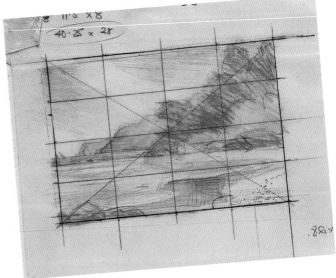

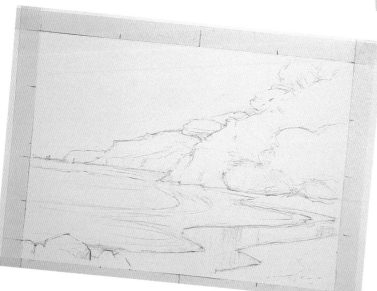

PREPARING TO PAINT

Having drawn up the outline under-drawing on watercolour paper, the view is cropped with masking tape to reduce the width, and then taped onto the board. Colours are chosen for the palette. Two essential colours for a sun-filled seascape are Prussian Green, which, in a dilute version, captures that sea-over-sand turquoise colour, and Raw Sienna, a natural pigment that is the colour of a sandy beach.

Aerial perspective and colour temperature

The approach to variation in colour temperature discussed in **Step 6 lost and found edges** – placing warm against cool and vice versa – also applies in landscape painting. However, colour temperature is also affected by aerial perspective. You will have noticed how hills appear blue in the distance. This is due to atmospheric conditions that make colours become paler and more neutral in the distance. Colours also become cooler the further away they are. Using paler, more neutral colours for distant objects will provide a sense of depth to your landscape painting.

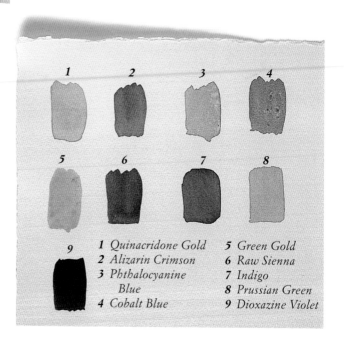

1 Quinacridone Gold	5 Green Gold
2 Alizarin Crimson	6 Raw Sienna
3 Phthalocyanine Blue	7 Indigo
	8 Prussian Green
4 Cobalt Blue	9 Dioxazine Violet

PAINTING THE SEASCAPE

The artist's plan is to start at the top of the painting with the sky, feeding in colours wet in wet to produce a variegated wash, similar to the background practised in **Step 9 creating drama**. The middle-ground starts with the furthest point of land, and comes forward along the right-hand headlands with warmer and brighter washes wet in wet. The sea is next, painted wet on dry, starting at the horizon. The sand is added wet in wet. Finally, the painting is balanced and the details added, but subsequently first aid is applied to reorganize the waves.

Stage 1

1 First, the highlights and fiddly details are reserved with masking fluid: a small boat in the distance that could easily be painted over and the edge of the sea on the sand. The latter has a rough edge to represent the line of spume that heads a wave as it rolls up the beach.

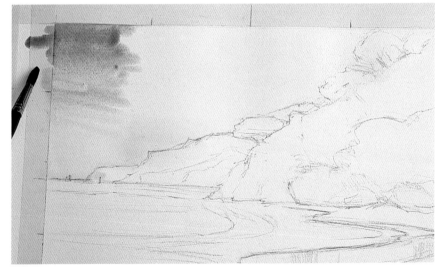

2 The variegated wash for the sky is next. Wet the sky area with a brush and clean water. Take the water down just below the outline of the hills on the right, later this has the effect of linking the sky with the land. The first colour to feed in along the top is Raw Sienna, with a little Alizarin Crimson added down by the horizon – take off any excess with a tissue. Allow the pale yellow to sink in before adding the blue, first warmer Cobalt Blue on the left and then cooler Phthalocyanine Blue on the right. Leave a patch just off centre for the cloud. Take the blue below the outline of the hills on the right.

3 Add a little more Raw Sienna and Alizarin Crimson on the horizon. It may look extreme but because it is wet in wet, it will dry much paler. Now tip up the board and control the blending of the colours. Encourage the blue to merge with the warm yellow on the horizon and wipe off any excess paint.

 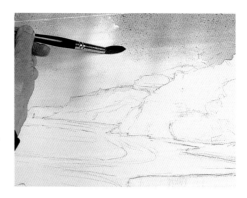

4 Still wet in wet, strengthen the blue at the top. Allow it to run downwards and blend with the previous washes.

5 Any stray runs of paint that gather along the edge of the masking tape will need to be cleaned off with a tissue or it will seep underneath. The paper is buckling, as the wash is very wet. It will flatten out again, once dry. Tip the board to make sure the paint does not dry in a trough. Watch the wash as it dries, controlling it by tipping the board. As the cloud will be on the diagonal to the left, you will want to tip the board down to the left.

6 To lift off the diagonal cloud, screw up some tissue into the shape you want. Press it down on the paint and lift off. If you do this more than once, use a clean piece of tissue. This will leave you with a wide range of subtle neutral tones in the cloud, from white where the paint is lifted off down to the paper, to yellow where the blue is taken off, to areas of grey where the blue and yellow merge. Soften any hard edges on the shadow-side of the cloud with a clean damp brush (see detail). Where the sun shines on the cloud, the edge will be harder.

Stage 2

7 The sky is finished. Dry with a hairdryer, but wait until the paint has been absorbed before you start or the rush of air will move the paint around. You can see how the sky colours have merged and flattened in the drying process.

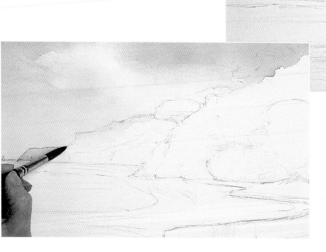

8 Exhibiting the effects of aerial perspective, the far-distant headland can just be seen against the sea and sky – a pale blue-grey promontory of land. Add a little Raw Sienna and Alizarin Crimson to the sky colour for this blue-grey.

9 For the next headland, the same colours are used but kept more separate. Use Raw Sienna with the sky blues and a touch of Alizarin Crimson to knock back the colours and make them more neutral. They need to be neutral and not too bright or they will not stay in the background. Encourage them to blend by tipping the board.

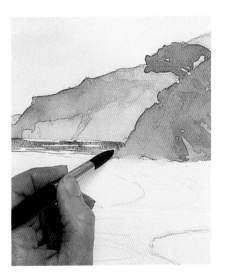

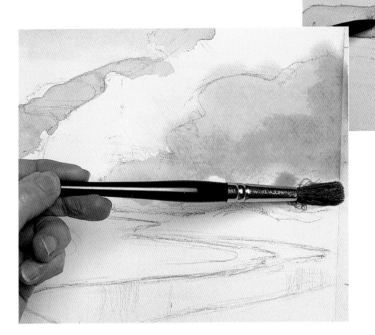

10 The foreground headland is much closer so the colours are warmer and brighter. The vegetation needs to be lush. The colours will go on wet in wet but in strong mixes – Green Gold mixed with the sky blues. Wet the area with water then feed in the paler Green Gold. Allow the gold to settle then add the blue to make green.

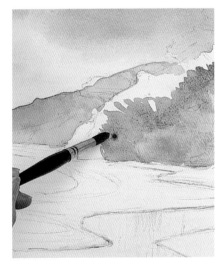

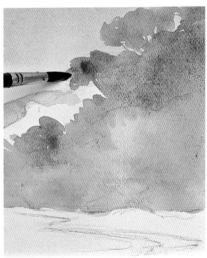

11 With a mix of the blue and yellow, use wispy brushstrokes along the edge of the headland, reproducing the outline of the vegetation with the very tip of the brush. Let it run in with the wash below and with the sky colour.

12 Extend the trees along the ridge and feed in Raw Sienna to increase the tone.

13 To paint the sea, start on the horizon with a dark neutral (the sea where it meets the horizon is nearly always darkest, disobeying the laws of perspective). Use Indigo or a mix of Prussian Green with a touch of Alizarin Crimson to neutralize it.

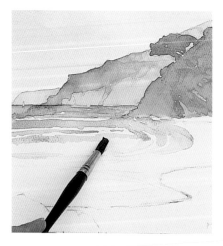

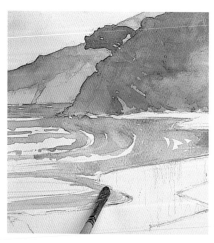

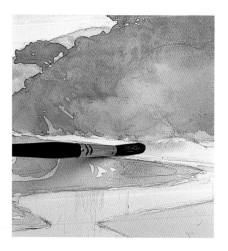

14 Come forwards, down the page in bands, leaving slithers of white paper showing between. Vary the colour between Cobalt Blue and Prussian Green and bring in a little Dioxazine Violet to warm the colours as you come forwards.

15 Sweep round into the bay on the right and as you come forward into the shallow water, add Raw Sienna to neutralize the colour. Use a hog-hair brush to produce a broken dry-brush stroke along the wave.

16 Paint in the sand with Raw Sienna and a touch of Alizarin Crimson, wet in wet. Wet the paper first with water and touch in the colour.

17 Let the painting dry and take the opportunity to stand back and take an objective look. It should be coming on well. The headlands are set firmly in the picture space, appearing to recede into the distance. The next step is to paint in the strip of sea-covered sand along the shore, which will reflect the landscape above it and build up the contrast overall.

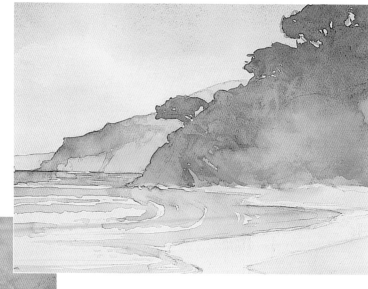

Stage 3

18 Now work on the reflections in the wet sand. Start with a wash of warm Raw Sienna with a touch of Burnt Sienna, taking it over the sand in the foreground. Then add, wet in wet, variations of Raw and Burnt Sienna, Cobalt Blue and Alizarin Crimson – mixed to a neutral grey in the foreground, and a mix of green added to the yellow where it reflects the lush vegetation in the background. The colours look extreme when they go in but they will dry paler.

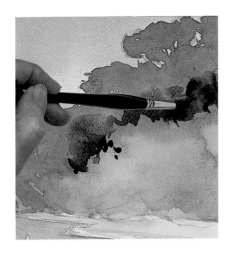

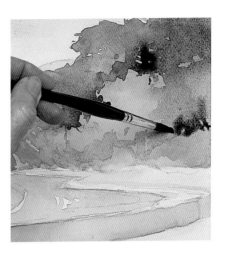

19 The foreground headland needs the contrasts and details building up. Wet the area with water and then work in some Prussian Green with a touch of Alizarin Crimson with the same wispy strokes as used in Step 11 (see page 125) to describe the vegetation.

20 Spatter some of the same mix over the area to break it up a little. Tap the filled brush down on another clean and dry brush (or you will have two sets of spatter).

21 For the rocks between the vegetation and the sand, paint in some Burnt Sienna and a touch of Phthalocyanine Blue for a red-brown and draw it out with the end of the brush, then add a darker mix of brown to increase the contrasts. Take this mix on to describe the rocks on the headland.

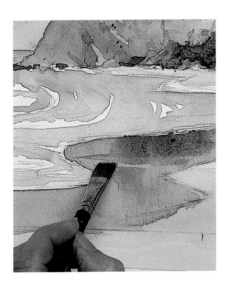

22 Coming back to the reflections on the beach, wet the paper again and add further dark greens. Allow to dry and then lift off horizontal strips with a flat brush to make pale stripes across the area. This has the effect of flattening the reflective film of water, which loses its dimensions otherwise.

23 Add the foreground rocks in the bottom left corner, using mixtures of Raw Sienna, Burnt Sienna and Phthalocyanine Blue. For some graphic marks draw out the paint with the sharpened end of a brush. Be restrained; these rocks should not stand out too much – they just need to stop the eye dropping off the edge of the page.

24 Using a more dilute version of the same paint mix, spatter pebbles over the, now dry, seashore and then smudge them unevenly with a piece of tissue to soften them.

25 Use a rigger brush to glaze over the waves in the sea with some pure Prussian Green.

26 Remove the masking fluid with a putty eraser. It reveals the edge of spume along the shoreline.

27 The sailing yachts on the horizon go in, dark against the pale sky. Use a mix of Prussian Green, Cobalt Blue and a touch of Alizarin Crimson. Take care, they are in the far distance and should be a similar tone to the sea. Even such a tiny detail can be executed with the very tip of a size 12 brush.

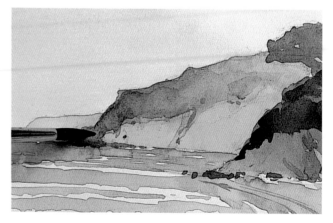

28 The painting needs some bite and the contrasts need further attention. This means adding more darks and more colour. First, another layer of Prussian Green is added to the headland wet on dry. Keep the brushstrokes wispy by using the tip of the brush.

29 Carry on around the painting, adding another layer of colour to increase tone and sharpening up areas with small points of dark. Do not forget to use paler colours in the distance, as on this headland.

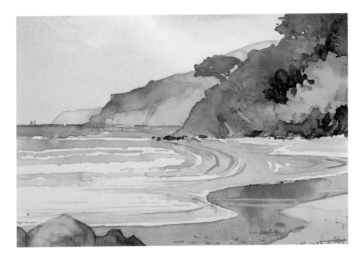

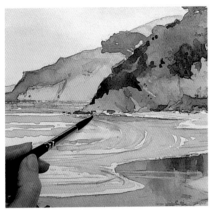

30 You can see how the whole painting has been 'bumped up.' For softer increases in tone, such as those in the reflections on the sand, wet the area first. Add wet on dry for sharper edges such as the foreground rocks. Notice that this extra layer of tone is warmer in the foreground and cooler in the background. Satisfied with the tonal balance, the artist is now concerned about the waves coming into the bay on the right. This will need first aid.

Stage 4

31 First, the artist uses a hog-hair brush and water to remove the contrasts in the waves striking right into the bay, extending the horizontal wave highlights. This horizontal element is increased by taking the band of Cobalt Blue and Prussian Green across to the right under the rocks.

32 With a scalpel, horizontal highlights are scratched out to add an edge to those already removed with the hog-hair brush.

33 A violet glaze of horizontal wave shadows is applied, joining up the waves across the bay.

This is really a demonstration of how nothing is ever lost. Watercolour, though giving the impression of being unforgiving, is quite the opposite. This is one reason why you need good watercolour paper – it allows you to rectify mistakes or change direction halfway through, so that you have a painting to be proud of at the end.

painting flowers

For this project we are going to paint a wonderful vase of slightly overblown tulips, their petals wide open to display their dramatic inky black centres. Painting flowers is an art in itself and requires a more specialized palette of colours. You will see in this demonstration, and in the careful preparation, how to capture the beauty and freshness of these blooms. You will also see how you can inject energy and drama into what appears to be a static display through organizing the composition and planning the juxtaposition of colour and tone.

Materials

Paper for sketching

Watercolour paper, 300 gsm/140 lb

Masking fluid

HB clutch pencil

Round brush, size 12

Round brush, size 6

Hog-hair brush

Rigger brush

Old brush to apply masking fluid

Tissue/kitchen paper

Atomizer

Watercolours:

- *Quinacridone Red*
- *Permanent Rose*
- *Quinacridone Magenta*
- *Dioxazine Violet*
- *Cobalt Turquoise*
- *Winsor Green*
- *Prussian green*
- *Translucent Orange*
- *Transparent Yellow*
- *Green Gold*

Backlighting: These glorious tulips are lit from behind, creating promising contrasts between the highlights on the top edges of the flowers and dark background.

PREPARATORY WORK

The artist has spent some time in preparing for the painting: first adapting a photograph of the tulips into a working composition, then making a tonal sketch and plotting a pathway of light through the many blooms to lead the eye around the painting. Finally, once the outline drawing has been made, the artist works out the distribution of warm and cool colours to strike a balance and to inject some energy into the painting.

Adapting an original photograph

The aim of this still life is to capture the spirit of the original vase of flowers but the arrangement will be better if it is tidied up, with a few of the blooms edited out. The containers are given a makeover – one plastic bucket and a jam jar are converted into two elegant vases. Take care not to order reality too much in such an exercise; the result needs to look natural. An outline drawing is made and then enlarged on a photocopier before being traced onto watercolour paper (see page 39).

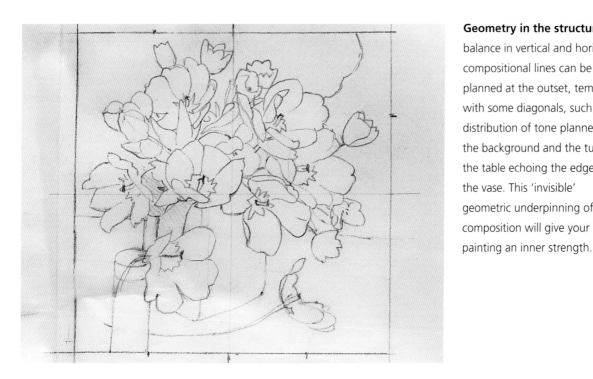

Geometry in the structure: A balance in vertical and horizontal compositional lines can be planned at the outset, tempered with some diagonals, such as the distribution of tone planned for the background and the tulip on the table echoing the edge of the vase. This 'invisible' geometric underpinning of your composition will give your painting an inner strength.

Geometric underpinning

Although it is not immediately obvious, a geometrical structure underpins the adapted drawing. This is not taming an unruly composition but a nod to a structure that gives the composition a strengthening framework.

You can see how this is done in the sketch: the tulip shapes should be distributed, not necessarily evenly, but in a balanced fashion over the picture area. This area is divided into quarters and then sixteenths. The artist has plotted this underlying structure with compositional lines, such as edges of petals and leaves, and extremes of tone – light and dark points.

Counterpoint

A tonal sketch looks at the overall balance of tone, devising a plan for counterpoint where the pale (yellow) tulip is pitted against the dark background at the top left, with the darker (red) tulips seen against the light-filled area on the right. The flowers could become muddled together so the artist arranges the tones so that tulips in the shadows show highlighted petals and those in the light have areas of deep shadow. The dark background is added on a diagonal to counter the horizontal and vertical features in the vases and flowers.

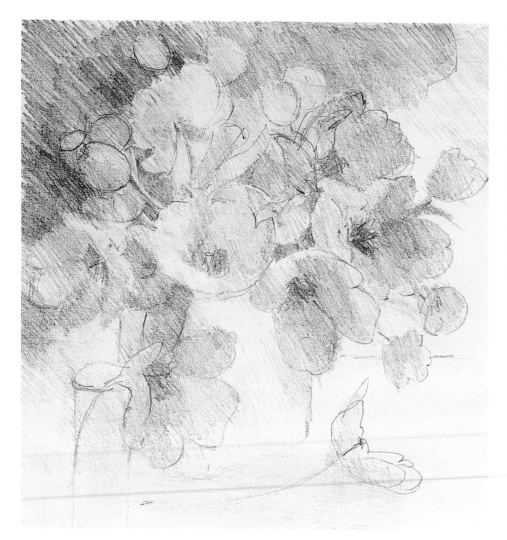

Manipulating the tone: A tonal sketch explores the distribution of light and dark in the composition. The light is coming from above at an angle, from behind right. The light in the tonal sketch is softened so that the single bloom in the foreground can be seen in the shadows. It means the colours will not be as extreme as in the photograph.

Pathway of contrasts

The tonal sketch also explores a pathway of contrasts which lead the eye in a circular motion around and through the composition. Starting from the middle of the left-hand side, the contrast between the background darks and the light table catches the eye and draws it into the flowers, leading it via patches of highlight and the dark tulip centres in a broad sweeping circle.

Temperature map

On a photocopy of the outline drawing the artist maps out the areas of warm and cool colours – W = warm, C = cool – juxtaposing them throughout the painting. Warm flowers will be backed by a cool background and vice versa. In the finished painting, you will see that these temperatures are subtle but they will add an intangible energy to the picture. With a complicated composition, it is easy to forget the plan, so you will find a temperature map a useful reference.

Warm and cool colours: Map out areas of warm and cool ('W' and 'C') colours on an outline sketch. This will be a useful reference when painting the flowers.

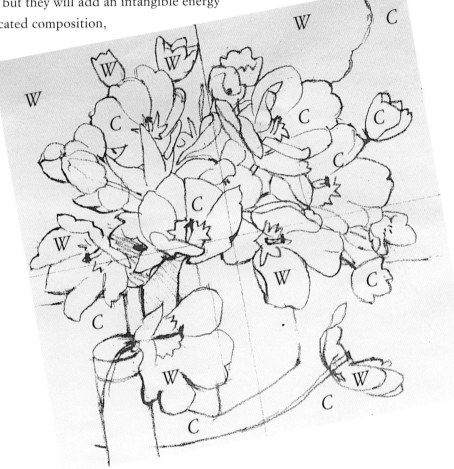

PREPARING TO PAINT

Flower painters tend to use a more specialized palette than other watercolour painters because some colours are impossible to mix and are specific to the flowers being painted. Deciding on this palette will be our first job (see Materials, page 130). A flower artist seeks out a range of the most transparent hues in an attempt to capture the fresh vibrant colour of flowers. Here, the artist looks at the tulips, trying to foresee any problems that might arise in mixing these vibrant pinks and oranges. Two useful, wonderfully powerful colours are chosen: Permanent Rose and Translucent Orange. The paper is taped on to the board and we are ready to go.

PAINTING THE FLOWERS

The process for this painting is similar to the still life, starting with general washes and then building up colour and form. To keep the flowers vibrant, it is important to keep your colours clean and to make sure that shadows on the flowers are built up with as pure colours as possible, avoiding neutrals.

Stage 1

1 Use masking fluid to reserve highlights on the edges of petals and the zigzag pattern around the centres of the tulips. Once dry, spray the whole area with water and allow it to sink in. Start with washes: first cool Transparent Yellow is spread over the flowers; the left side is warmed with Quinacridone Red while the bottom left and right are cooled with palest Cobalt Turquoise. Permanent Rose is then added to the centre. Tip the board to control the washes and take off any excess with a tissue. Keep the paper damp by spraying with a fine mist of water.

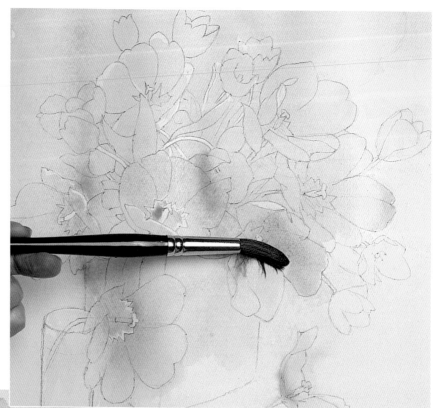

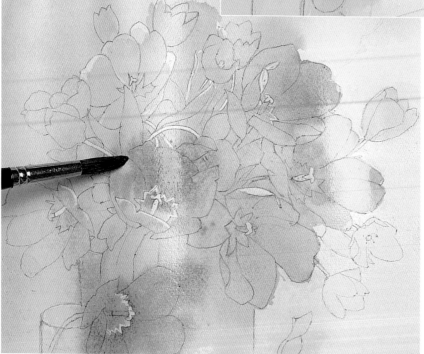

2 Reinforce the colour wet in wet, but make sure the first washes have had time to sink in or the superimposed colour will take over. Add red, blue and yellow in warm and cool versions including the cool pink Permanent Rose. Take care with the edges of the petals on the right-hand side – these are seen against the light so need to be precisely outlined even at this stage. You can see where the masking fluid is doing its job.

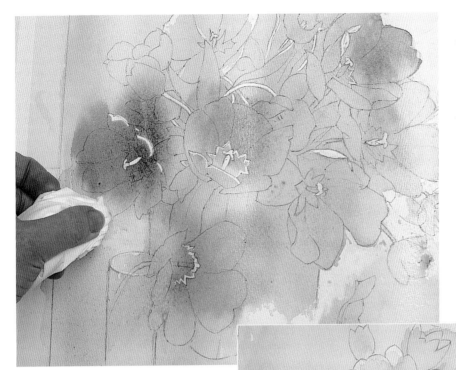

3 Referring to the tonal sketch, you need to keep a soft-edged area of light clean above the tall thin vase, bottom left. Dab this area with tissue to lift the paint. You can see how the warmer violet blues have been built up in this area.

4 Now apply a thin wash of Phthalocyanine Blue over the yellow under-wash to plot the greens and to start to give the tulip petals some negative shape. Do not let the green run into the red or a neutral grey will result.

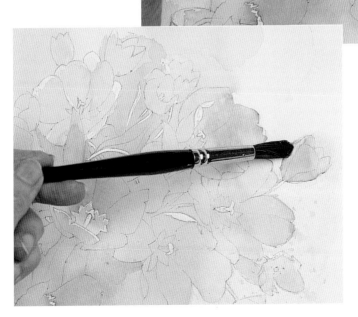

5 Spray with water to blend and soften areas. Use your hand to mask areas that you do not want softened. The pale purple tulip on the right edge is at the back. It is in a cool area (see page 133), and therefore its colour is more neutral so some of the Cobalt Turquoise background is allowed to wash over it. Allow to dry.

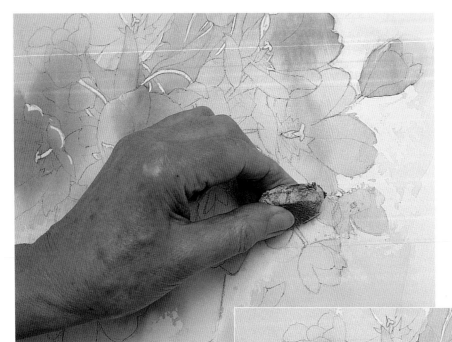

6 Take the masking fluid off around the edges of the petals but leave it on the details in the centre of the flowers. If you leave highlights too long they will be too stark and hard-edged.

Stage 2

7 The early washes are down and the colours and temperatures mapped out, although nothing is set in stone. You can begin to see the subtle development of areas of warm and cool colours: warm across the top left-hand area, cool at the bottom left. Pitted against this is the cool yellow flower, top left, and the warm red flowers in the lower half of the painting.

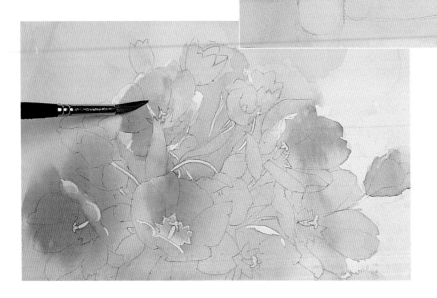

8 Now you begin to build up colour so your paint should be less dilute. First, strengthen the yellows, wet on dry, which will also allow for more hard-edged petals. Start with the cool Transparent Yellow on the tulip at the back.

9 Not all the flowers are reinforced with the same colours: the red flower to the left is given a layer of the Transparent Yellow to produce a rich orange. Next build up the pink flowers and then reinforce the greens behind, bringing out the shapes of the petals. The single tulip in the smaller vase is treated in the same way.

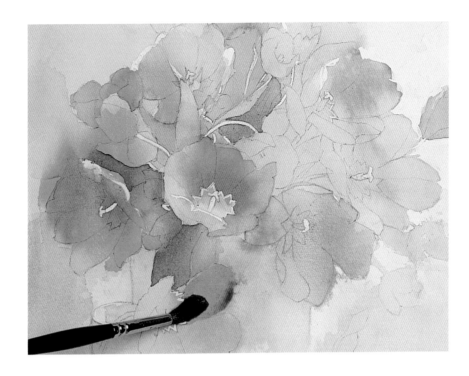

Stage 3

10 Once the painting has been allowed to dry, more colour is added: Permanent Rose over the yellow make a lush scarlet for the central right flower. The colour is added unevenly over uneven layers beneath so that it is not flat. The form is developing too, with pale edges set off against darker petals and background greens enforcing the negative shapes around the petals.

11 Allow the painting to dry and then look at the balance of tone against the tonal sketch. The artist uses a hog-hair brush to reinstate the 'pathway of light' where some highlights have been painted over or are not bright enough. Gently lift off paint with a little water and blot with a tissue.

12 Now we build up form with pure colour. The flower shadows go in wet on dry. This is an opportunity to separate petals and create some hard edges where dark is seen against light. Some more intense Translucent Orange is applied to the foreground flower to create a hard edge, seen against the lit up yellow top side of the tulip. Use the tip of the brush and paint carefully following the outline in the drawing. It is useful to have reference photographs for such details.

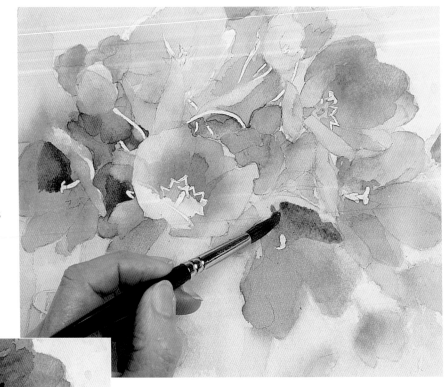

13 Give each tulip form in this way, using pure colour in the foreground and a slightly neutralized form (with a touch of the complementary colour) for the tulips at the back of the display. The addition of pure Permanent Rose has given form to the tulip, top right, giving it an intensity towards the centre, and working the negative space to form the backs of the highlighted petals. Permanent Rose over the yellow/orange forms the scarlet centre of this tulip.

14 Now the background colours go in but first make sure the tulips along the edge are quite dry. Before you start, remember the highlighted edges are not reserved and need to be negotiated. A combination of Translucent Yellow, Phthalocyanine Blue, Quinacridone Red and Dioxazine Violet produces a rich neutral brown. First, wash in a loose mix of the yellow and blue allowing the constituent colours to show. Leave chinks of white paper to energize the area. Paint carefully around the outline and take the green wash over the blues in the bottom left-hand corner. Now quickly add the red, wet in wet, clutching at various points and allow it to merge.

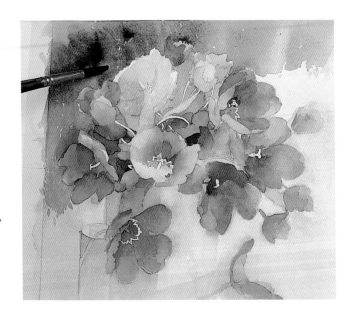

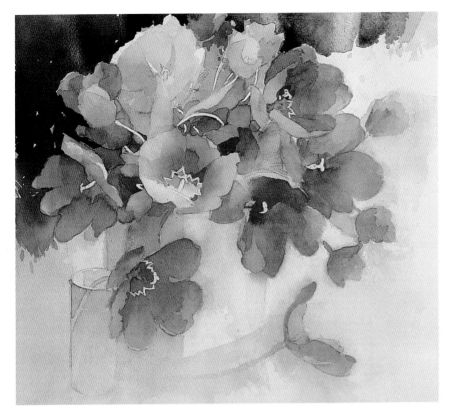

15 Add violet to build up the tone. The wash has caused the paper to ripple and the paint to fall into the troughs, gathering along the edge of the flowers. The artist wants a build up of tone along the edge, but if there is too much it will dribble across the flowers. Keep moving the board to stop it collecting and if there is too much, take it off with a damp brush. Once the paint has been absorbed into the paper, you can dry it with a hairdryer and the paper will flatten out. Note, compared with Step 10 (see page 137), how the small vase has been brought on, taking a wash of violet wet on dry to form the edge of the vase, working it around the stem.

16 You can see how the background has dried, paler but with points of extreme tone along the outline. These tonal extremes need to be carried through the painting to maintain balance. They can be found in the darkest tone of the greenery, seen between the flower heads. First, a mid-tone green is added to the underlying green washes describing these interstices. The same green is used to delineate the edges of the vases and the stalk of the tulip lying on the table (see detail). For the darkest shadows, use a mixture of Green Gold and Dioxazine Violet. Very carefully paint in further interstices, creating a focus of contrasts with the highlighted stalks.

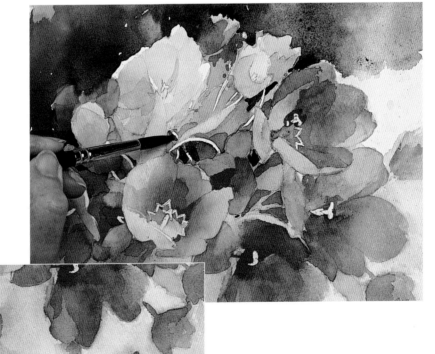

17 The artist's plans to create interest in the painting are coming together. There is variation in extremes of tone, colour contrasts, warm and cool colours, hard and soft edges. The focus of the painting is in the centre of the main bunch of flowers, so that the single bloom in the small vase and the tulip on the table are shown in less detail. Even within the bunch, some tulips are more in focus than others, bringing them to the foreground and giving some variation. There is variation too, in the outline as prescribed on page 131. The tulips at the rear are allowed to meld into the background with a soft edge; tulips that are more in focus have a sharp edge.

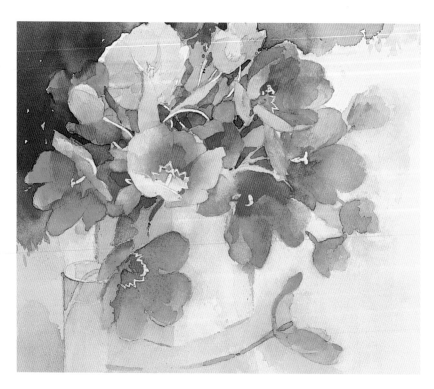

Stage 4

18 With a putty eraser remove the masking fluid from the flower centres, the lines around the dark zones and the pistils. Paint the pistils with a pale wash of green with the tip of a size 6 round brush. The pistil here is going to be seen against the dark of the central zone of the tulip and so is painted in the palest tone of green.

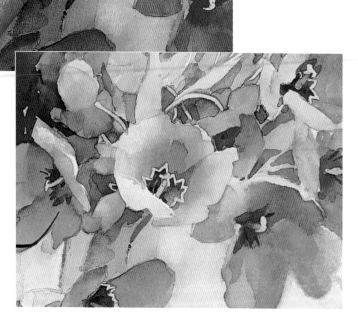

19 Add the dark centres with the small brush and some violet. Do not make them too solid or too even in colour, and vary the tone over the bunch of tulips.

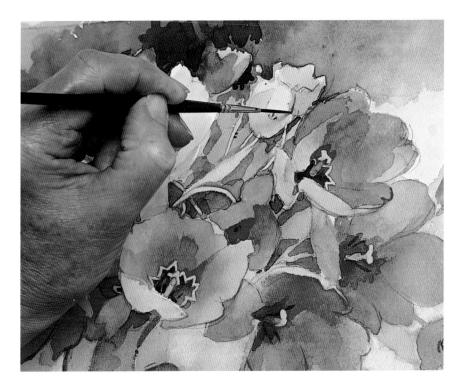

20 The final touches are made with a rigger brush – a fine brush with long hairs that paints an expressive line. The artist uses it to reinforce edges, using a dryish, strong mix of red. This process needs to be executed delicately – an edge here and there. Take care not to overdo it. The yellow tulips at the back are separated with a few delicate lines.

The final painting has been further developed – it is always difficult to know when to stop. The outline, top left, has been reinforced with a few directional strokes of violet painted into the background colour to increase the contrasts. The yellow light on the small vase is intensified to link it more strongly with the main display. Now the painting is finished and the result is truly engaging. The tulips pulsate with colour, drawing the spectator into the picture.

index

acknowledgements

Executive Editor Katy Denny
Editor Alice Bowden
Executive Art Editor Leigh Jones
Designer Miranda Harvey
Production Manager Ian Paton
Artist Adeline Fletcher
Photography Paul Forrester © Octopus Publishing Group Limited